BONES OF THE EARTH, SPIRIT OF THE LAND

The Sculpture of **John Van Alstine**

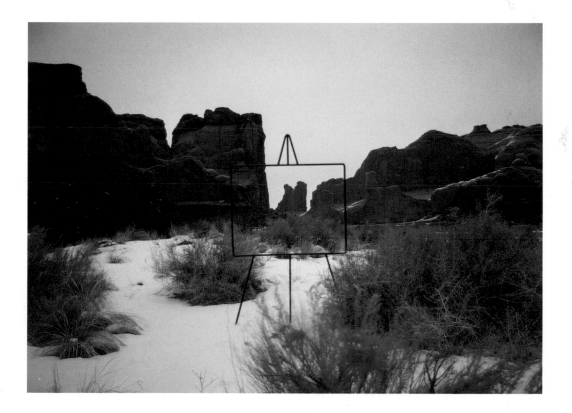

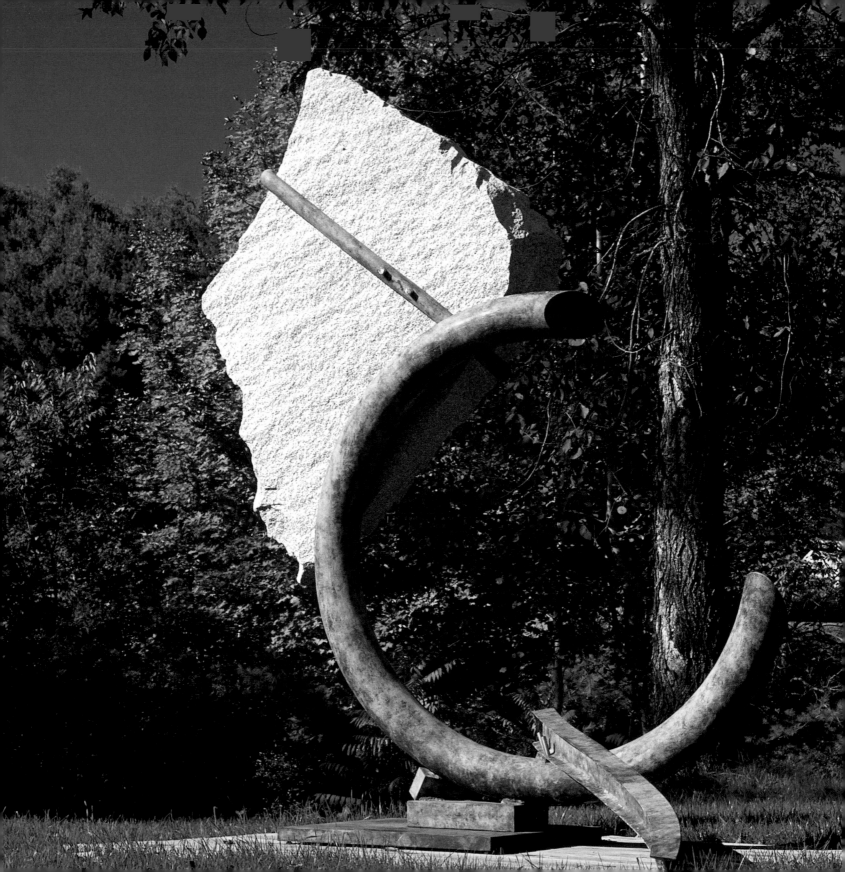

BONES OF THE EARTH, SPIRIT OF THE LAND

The Sculpture of

JOHN VAN ALSTINE

Essay by Nicholas Capasso
Interview by Glenn Harper
Edited by James Grayson Trulove

Photography by John Van Alstine

In dedication to my father, Richard Van Alstine. Thank you for your generous and unwavering support.

JVA

First published in the United States of America by:
Editions Ariel
1700 17th Street, NW
Suite 505
Washington, DC 20009
Tel: (202) 387-8500

ISBN: 0-9679143-0-2

10 9 8 7 6 5 4 3 2 1

Printed in China.

Cover: *Pique à Terre VI,* 1997
Granite & steel
58 x 106 x 50 in.
Half-title page:
Arches Easel Landscape, 1980
Full title page:
Tiller I, 1994
Granite & bronze
96 x 93 x 64 in.
Left:
Van Alstine's studio in Wells, New York

Contents

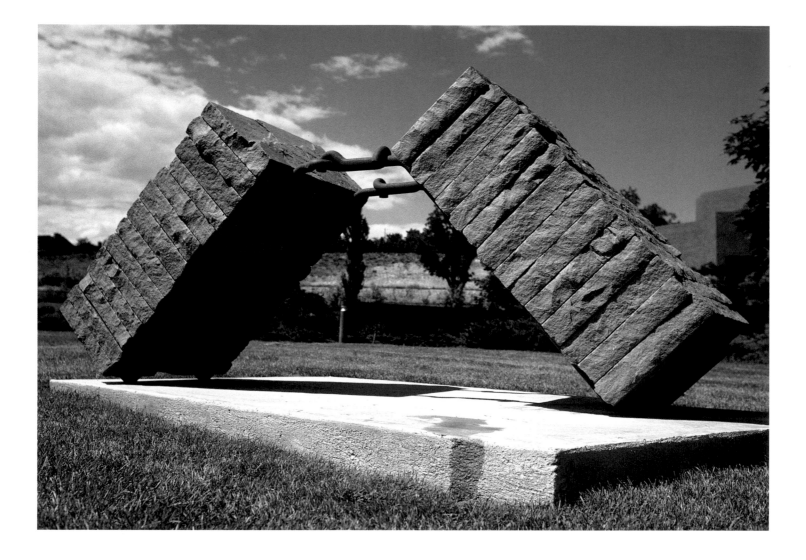

Arch #6, 1979
Stone & steel
46 x 102 x 39 in.

6 John Van Alstine

Bones of the Earth, Spirit of the Land

by Nicholas Capasso

When asked to consider the intersection of landscape and the visual arts, one immediately calls to mind images of two-dimensional art, namely landscape painting and photography. These two media — one ancient, and the other a product of the Industrial Revolution — allow for both conjectural and relatively objective pictures of our environs, seen always at some remove, as if through a window. Or, in a more contemporary context one might consider sculptural and architectural artworks placed within the landscape, such as the site-specific earthworks or land art pioneered by post-Minimalist artists Robert Smithson, Walter de Maria, Michael Heizer, and others in the 1960s and 1970s. These works are not images, but objects and places, inextricably tied to the land both physically and conceptually.

The sculpture of John Van Alstine occupies a unique territory, mediating amongst image, object, and place. Van Alstine is a sculptor, first and foremost, a maker of impermeable, obdurate, and often monumental objects. These objects, however, also have an imagistic quality, complete with the representational, associational, and metaphoric qualities inherent to pictures. Yet at the same time they speak strongly of place, in microcosmic and macrocosmic terms. Geology and cosmology collide. Narratives about and within landscapes are layered like sediment. Van Alstine mines the earth to excavate its beauty, its terrors, and its potential for the expression of powerful and subtle aspects of the human condition.

Even in Van Alstine's two-dimensional work — pastel drawings and color photography — his concern for the landscape as stage and actor is pre-eminent. This is not to imply that the artist's work is entirely delimited by his perceptions of the land. He deals also with the figure, the monument, abstraction, assemblage, storytelling (particularly myth), cultural history, and natural history; but a sense of the land, its gravity and embrace, its settings and stories, is the ground upon which all else rests.

Los Arcos, 1986
Granite & steel
8 x 6 x 12 ft.

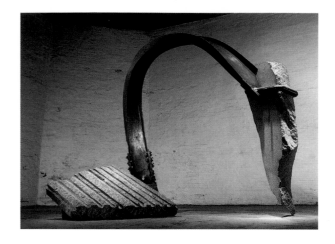

SCULPTURE

The hard root of the land is stone, and for Van Alstine, "stone is everything," the physical and metaphysical basis of all his work. None of his sculptures are without a stone, or the image of a stone. Stone is the earth and the land, stone is terra firma. Van Alstine uses stone as a place, a home, a figural presence, and a magical transformational material. Stone marries nouns and verbs, and dissolves the dualism of image and object.

Van Alstine grew up with stone, and lived close to the land, in the Adirondack Mountains. He saw rocky promontories, glacial granite boulders, stone walls, and split-stone fences in his boyhood travels through upstate New York and northern New England. As an art student, he saw stone as the foundation of the history of sculpture, and began to believe passionately that "stone is sculpture." Deeply impressed by the works of the ancients, he found compelling parallels in Modernist sculpture. Van Alstine began his career as a sculptor of stone by emulating the great abstract carvers of the twentieth century: Constantin Brancusi, Hans Arp, and Henry Moore. He chose white Vermont marble as his first medium for its softness, purity, and malleability, and with it he carved sinuous, sensual, biomorphic abstractions. Many of these works, like those of his chosen predecessors, referenced the figure with their verticality and suggestions of human corporeality, but many also were bound up with the land. One of his earliest sculptures, *Gaea,* 1973 (p. 11) is an homage to Mother Earth, while the roughly parallel edges in works like *Vertical Series #2,* 1974 (p. 11) were directly inspired by the tracks of skis in virgin snow (Van Alstine had been a competitive skier in his youth).

Soon, however, the young artist's interest drifted from the finely wrought elegance of early Modernism to the rough-hewn rocks used by sculptors like Isamu Noguchi. Van Alstine's intentions changed and matured. He was no longer interested in carving stone to reveal something else, but in allowing stone to retain its integrity, its natural weight, density, and texture. By respecting the stone, and allowing it to speak for itself on its own terms, Van Alstine was able to

summon forth a new and wide range of content. At the same time, he shifted his process from the subtractive method of carving to the additive method of collage in three dimensions. In 1975, he embarked upon a series of *Stone Assemblages*. These were large-scale outdoor agglomerations of rough-cut stones, straight from the quarry. To these he sometimes added wood and steel elements in sprawling compositions that dealt with the formal tensions among the three disparate materials. With the *Stone Assemblages*, Van Alstine laid out the beginnings of the material, procedural, and compositional underpinnings of all his later work.

In 1976, John Van Alstine moved to Laramie, Wyoming, to accept a teaching post at the local State University. While there, his love of raw stone deepened, and his interest in landscape intensified. In Wyoming he saw the land stripped bare, and saw clearly for the first time the awesome power of nature as sculptor. The rocks of his boyhood back east had been nestled in soil, swaddled by greenery, and framed by the closely compacted rolling topography. Out West, aridity, erosion, and the vast and stark lay of the land combined to produce an unfamiliar sublimity. Mountains, buttes, stone arches, glacial scars, exposed geologic layering, and colossal boulders loomed about him and the real danger of rockslide and avalanche was ever present. The bones of the earth protruded from its desiccated flesh, and the landscape seemed a place fraught with potent and perilous tensions.

In a new body of work, the *Nature of Stone* series, Van Alstine set out to express his perceptions of this environment. He assembled huge sculptures using nothing but giant slabs of Colorado flagstone and forged steel rods. No pins or welds hold these materials together. Their structural integrity depends upon actual physical forces held in precise tensions and balances. In his *Stone Piles, Arches, Torques,* and *Props,* the artist interlocked conflicting masses and weights in arrested motions that strain with potential energy. They are visually and physically precarious – their crushing capabilities are palpable – and their scale and compositions echo the exposed geology of the Western landscape. The *Nature of Stone* works explore not only the bald facts of rock, but also deal with the tortuous forces that underlie the landscape, the primeval tectonic writhing of the Earth itself and its potential for extreme physical danger.

In the *Nature of Stone,* Van Alstine worked within the then-current tenets of post-Minimalism, in which sculptors used minimal, predominantly geometric forms and the direct properties of materials to elicit emotional responses, often on a quite visceral level. In his next body of work, Van Alstine set himself completely apart from his art historical roots and his contemporaries. In 1980 he moved back to the East Coast to teach at the University of Maryland. Shortly after his return, he created a pivotal new sculpture, *In the Clear,* 1983 (p. 13). This artwork again brings stone and steel together, but now in harmony rather than strident discord. The stone and steel elements embrace, and work together, rather than seeming to try to pull each other to pieces. They dance, rather than fight. Moreover, *In the Clear* refers not so much to the structural properties of the landscape, but more to a sense of place. This place is, to be sure,

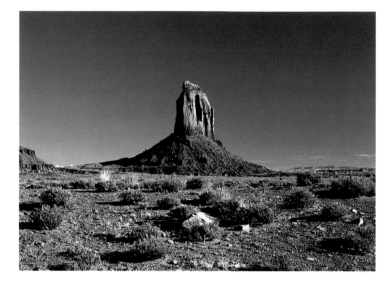

non-specific and highly abstracted, but it seems a place upon the land rather than a force within the earth. Van Alstine even went so far as to craft a vertical steel element that suggests vegetation. In subsequent sculptures, these direct landscape allusions proliferated as Van Alstine continued to introduce aspects of imagery within his dynamic formal and material assemblages.

In *Drastic Measures,* 1984-87 (p.18) and *Luna,* 1985 (p. 21), the artist began experimenting with applied color and quasi-representational shapes, to suggest plant forms, and the moon and sky, respectively. In *Los Arcos*, 1985 (p. 8), the soaring steel member that unites its stone foundations makes conscious reference to gigantic natural stone arches. And the compositions of all of these sculptures suggest vignettes within the landscape, places that can be imaginatively inhabited, and that are affectively distinct from each other. In contrast to the *Nature of Stone* series, these works are lighter, playfully evocative, and reflect the artist's fond memories of Western places rather than his direct experience of the powers of that land.

In the late 1980s and 1990s, Van Alstine arrived at the style and themes for which he has become best known. He continues to juxtapose stone and steel, but has added found objects and bronze castings of stones and found objects to his set of assembled elements. The work is ever more imagistic (especially given the presence of objects from the real world) and increasingly narrative. The landscape vignettes of the early 1980s seemed in part like empty stage sets waiting for players and actions. Now, mythological and metaphorical tales are told in sculptures wherein the distinctions between image/object/place and actor/action/stage are marvelously blurred.

Two primary themes in this recent work involve tools and vessels, and both are tied to Van Alstine's abiding concern with the land. Struck by the collection of nineteenth-century tools at the Smithsonian Institution's National Museum

Gaea, 1973
Marble
36 x 12 x 16 in.

Vertical Series #2, 1974
Marble
55 x 15 x 8 in.

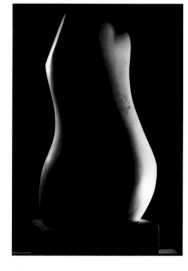

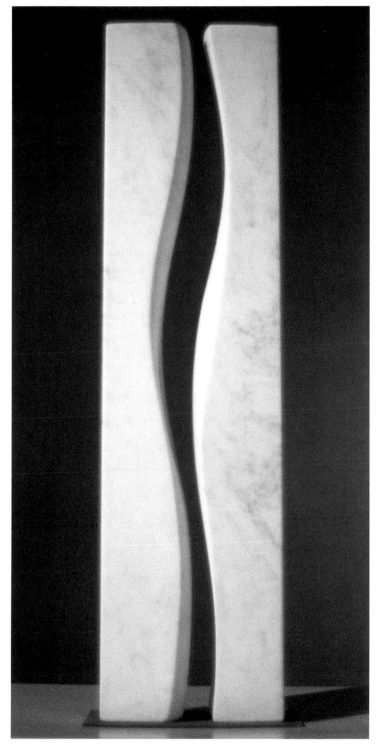

of American History, and following an art-historical precedent established by David Smith and Jim Dine, Van Alstine began to include actual utilitarian implements in his sculptural compositions. He was most drawn to agricultural tools - tools that help to work the land - and juxtaposed objects like rakes, plow blades, saws, and anvils with his ever-present stones in celebration of the joys and hardships of bending the land to one's will. Not surprisingly, he was particularly interested in the sledge, an antiquated conveyance on runners used for hauling stone over rough ground. In Van Alstine's *Sledges*, massive rock slabs become carrier and cargo, both the landscape and the laborious traversing of the landscape.

The *Sledges (p. 28)* – stone boats – also relate to Van Alstine's simultaneous involvement with the idea and image of vessels. The vessels – often with nautical associations that turn his sculptures into abstracted seascapes – involve metaphorical journeys across space, time, and place. Marine scrap yards in Jersey City, New Jersey, where the artist had relocated his studio, provided buoys, cleats, chains, oars, floats, and boats, to juxtapose with slabs of stone. In works like *Tiller,* 1994 (pp. 2-3), the stone flies aloft like a magical sail, and in the mythically titled *Atlas (High Roller)*, 1995 (p. 40), *Labyrinth Trophy*, 1996 (p. 38), and *Charon's Steel Styx Passage*, 1996 (pp. 36-37), the stones provide earthbound anchors for sweeping, orbital narratives that link land, sea, and sky, as well as ideas surrounding the boundaries between life and death. Other vessel sculptures address a type of transportation that is as technological as it is mythological. In *Tether (Boys Toys)*, 1995 (p. 40), a huge airplane fuel tank that resembles nothing more than a missile rises above a puny earth, and in *Sacandaga Totem*, 1997 (not illustrated), a central stone pylon provides the shaft to a rocket whose vertical aspiration is forever held in check by its mass. Works like these indicate Van Alstine's concern with the fate of the land, and of the earth, in the face of unchecked science and industry. Taken as a whole, the recent sculptures that involve tools, vessels, and voyages sum up and extend the formal and conceptual issues explored in Van Alstine's earlier work. They also establish places of contemplation not about landscape per se, but about humanity's many physical, cultural, and spiritual relationships with the land and our planetary home.

A great many of Van Alstine's recent sculptures are intended for outdoor display, and the grounds that encompass his current studio in Wells, New York (back in the Adirondacks) are filled with new work. In this rural setting, framed by mountains, dense foliage, and a river, the artist wrestles with issues of size, scale, placement, and sight lines so that he fully understands each sculpture's potential for outdoor display. His goal for all of his outdoor sculptures is to address not only the landscape intrinsically, but extrinsically as well, in direct dialogue with the natural features that surround them. Although not entirely site-specific, Van Alstine's large scale outdoor works do elicit meaning through their juxtapositions with existing landscapes, and also transform places from the mundane to the magical.

In The Clear, 1982
Granite & steel
8 x 10 x 6 ft.

U.S. western landscape

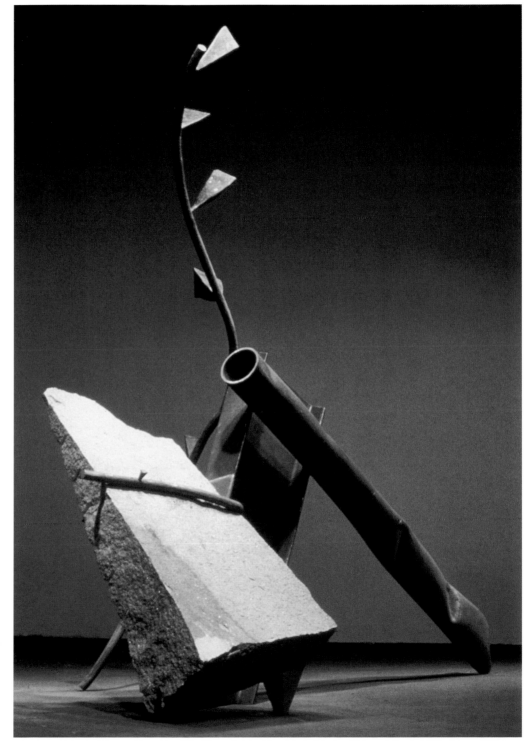

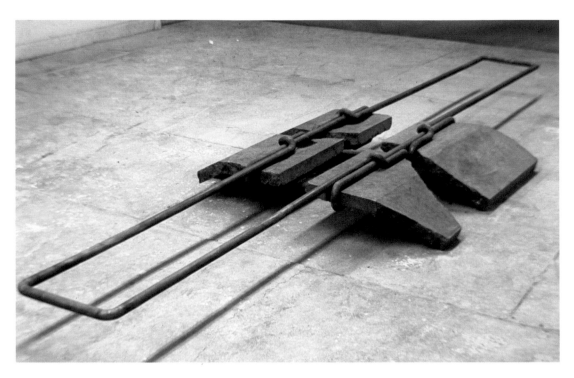

Boundary, 1976
Black granite & steel
19 x 164 x 43 in.

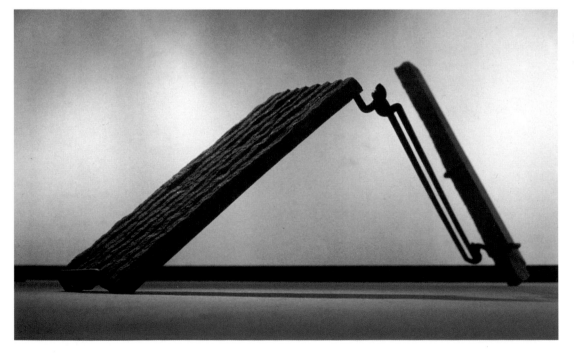

Torque, 1977
Stone & steel
57 x 167 x 68 in.

U.S. western landscape

Stone Pile #7, 1980
Stone & steel
7 x 7 x 7 ft.

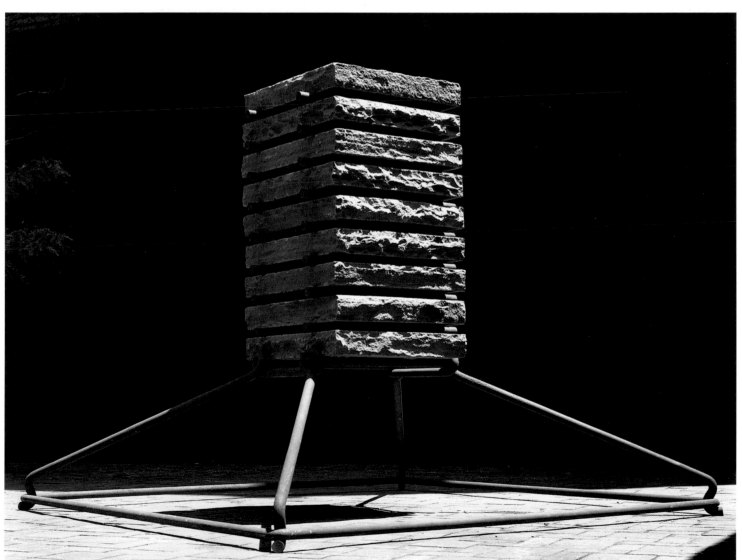

Big Go Round, 1983
Granite & steel
16 x 25 x 15 ft.

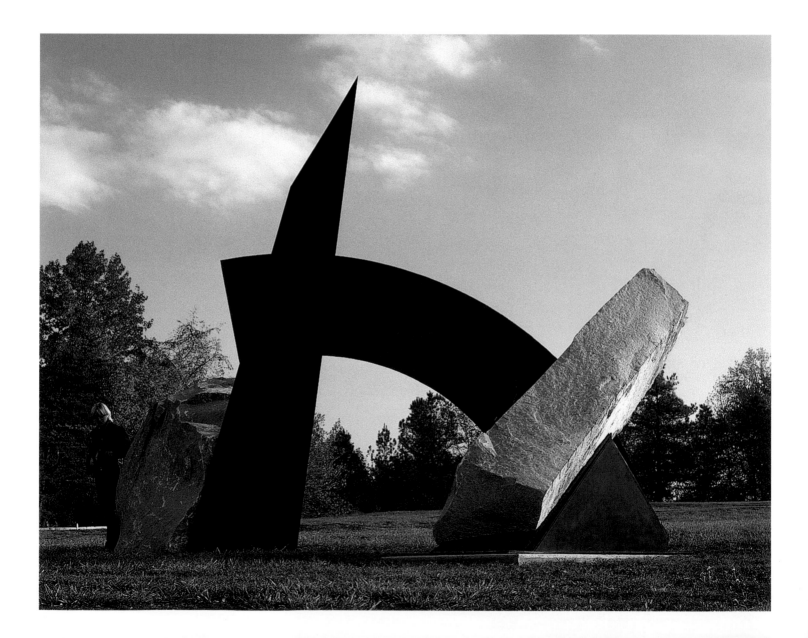

Slate Totem II, 1984
Slate & steel
10 x 4 x 3 ft.

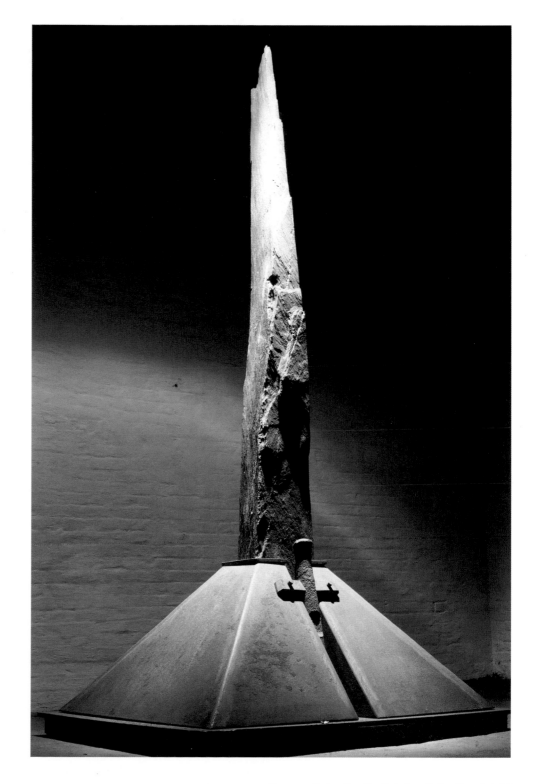

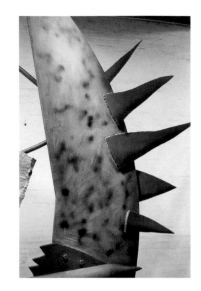

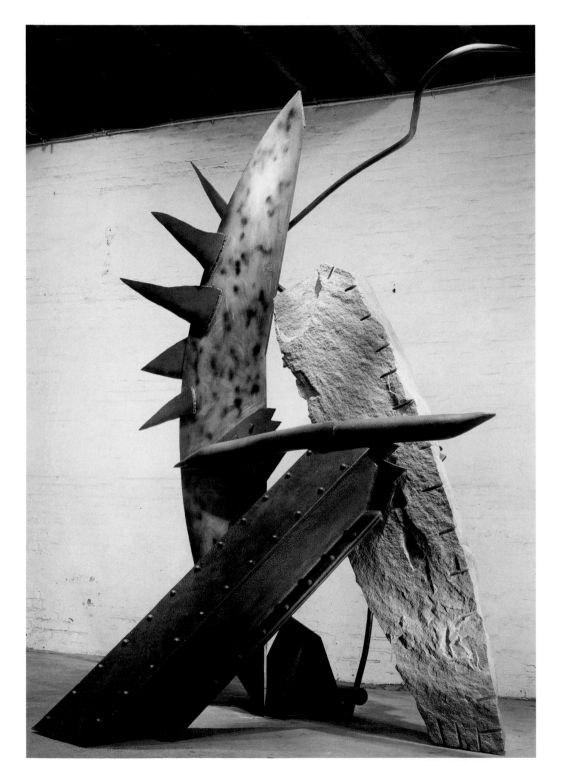

Drastic Measures, 1984-7
Painted granite & steel
12 x 12 x 8 ft.

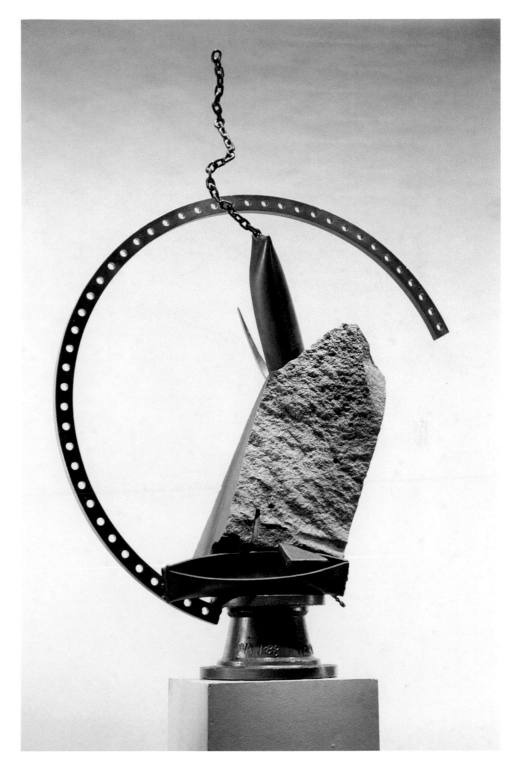

Portals & Passages, 1988
Painted granite & steel
70 x 54 x 36 in.

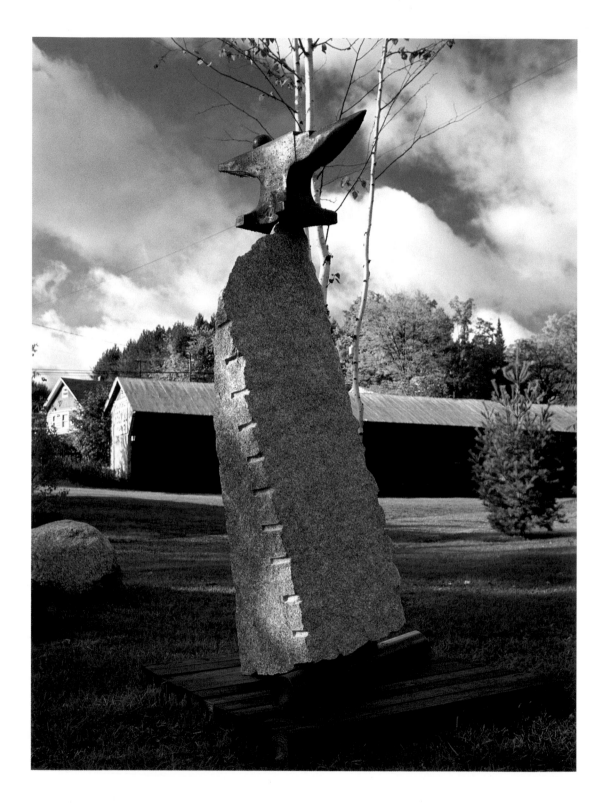

Ara I, 1989
Granite & bronze
78 x 22 x 38 in.

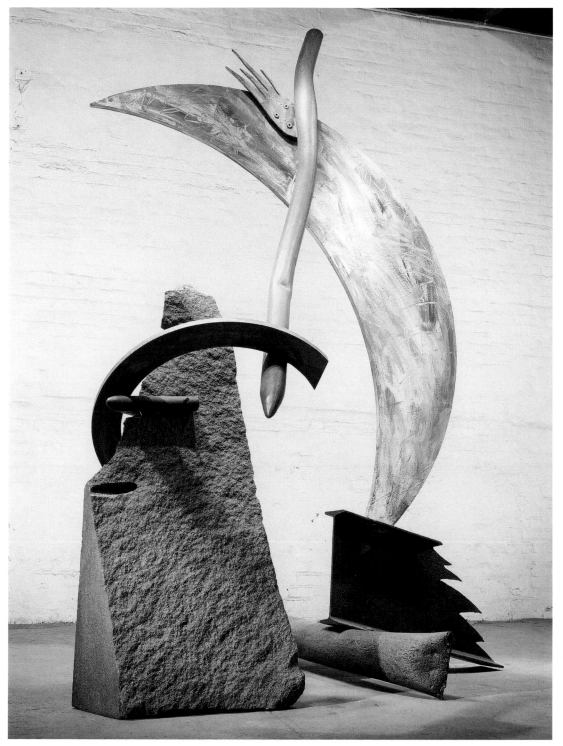

Luna I, 1985–7
Painted granite & steel
10 x 7 x 5 ft.

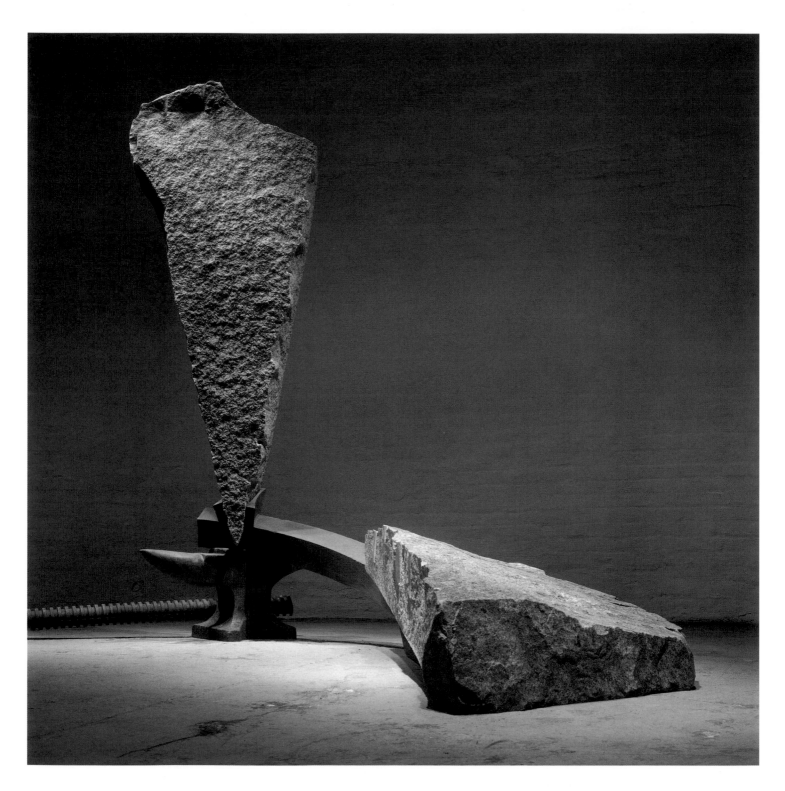

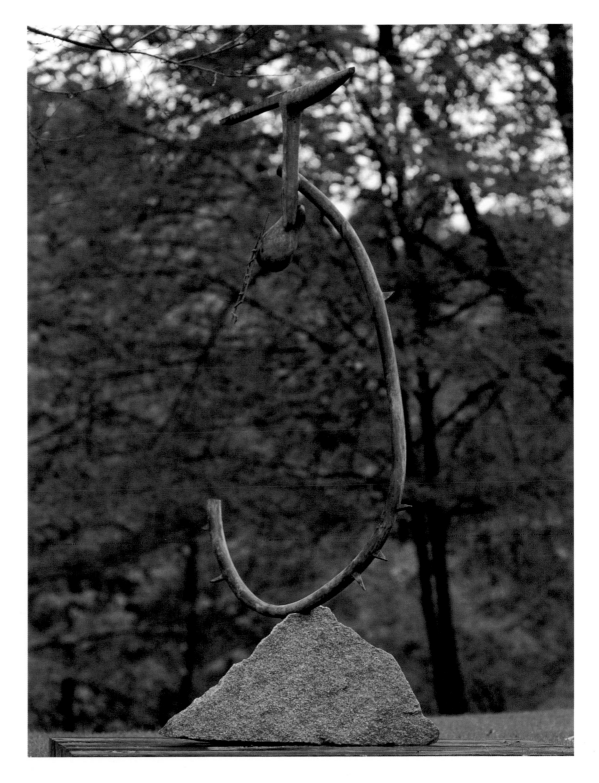

Odalisque, 1989
Granite & steel
81 x 98 x 60 in.

Strange Fruit VIII/
Close to the Heart, 1990
Bronze & granite
86 x 40 x 40 in.

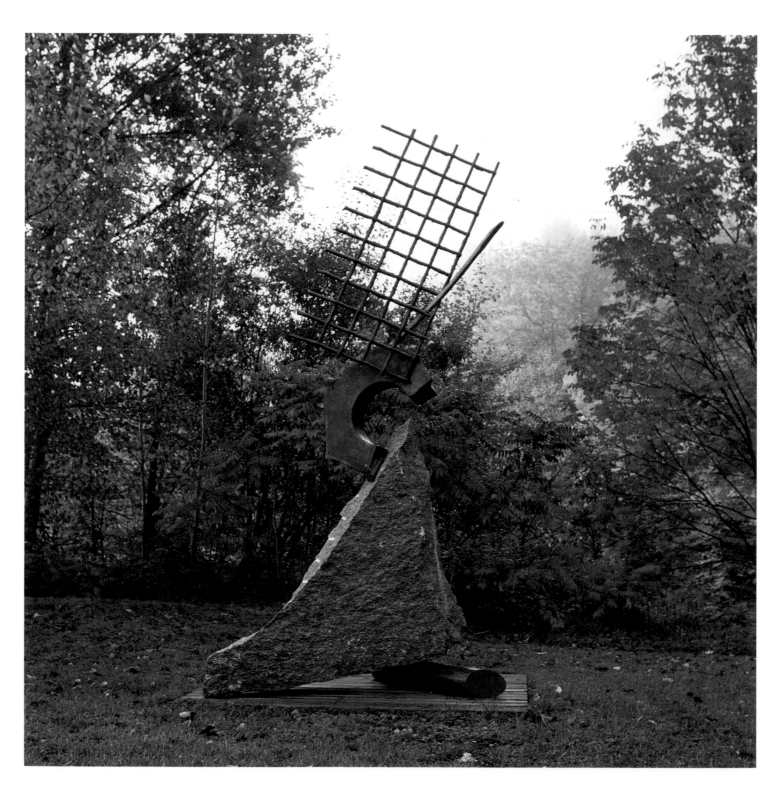

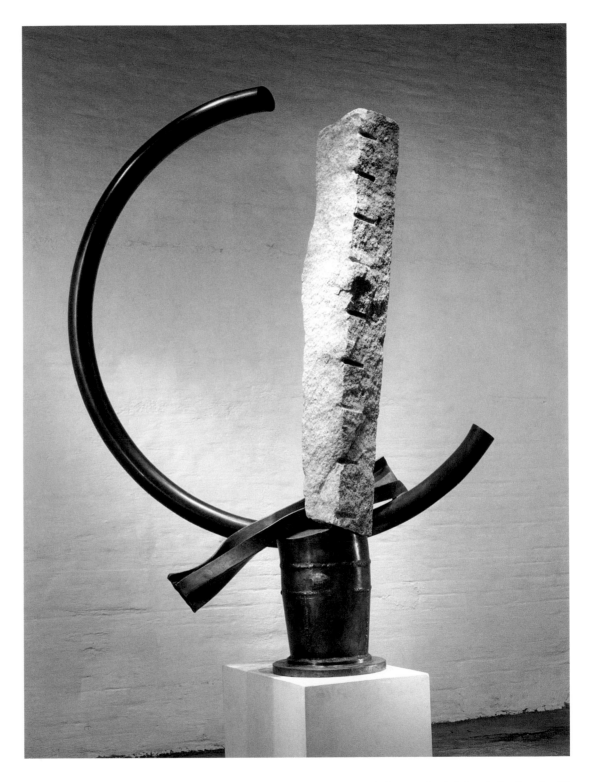

Working the Sails, 1990
Green granite & bronze
117 x 60 x 46 in.

Symplegades II, 1988–9
Bronze & granite
86 x 60 x 36 in.

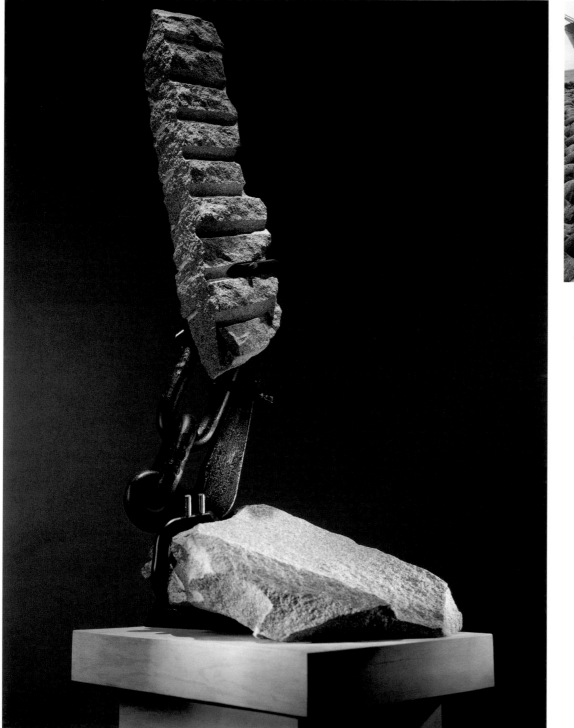

Lisbon, Portugal

Link I, 1991
Granite & steel
79 x 29 x 36 in.

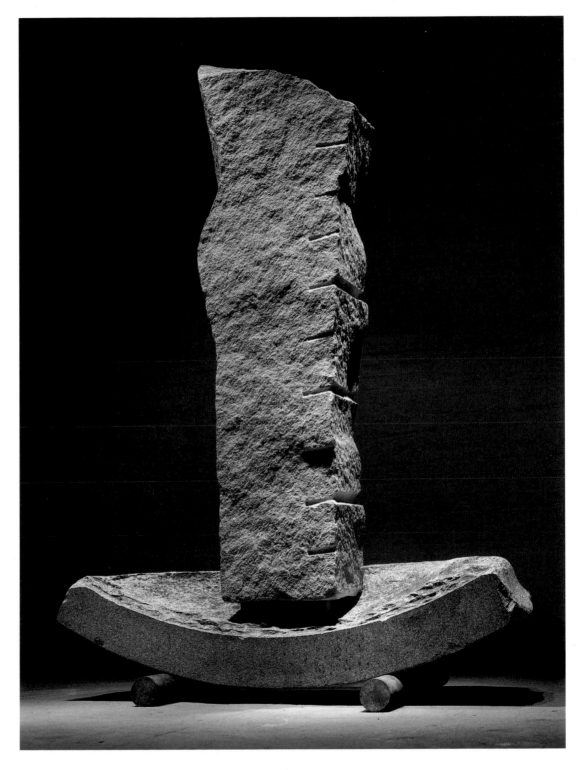

*Non Semper Ea Sunt Quae
Videntur,* 1991
Granite & bronze
80 x 60 x 27 in.

Sledge, 1992
Granite & steel
30 x 64 x 42 in.

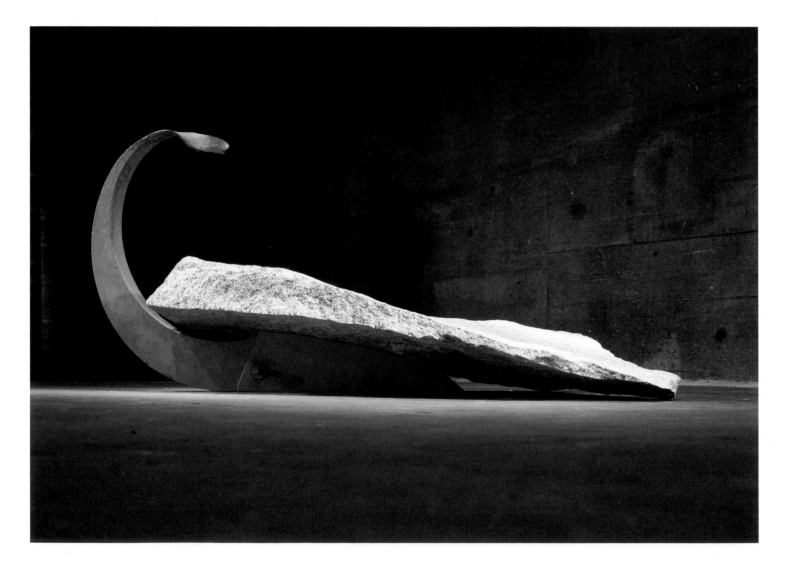

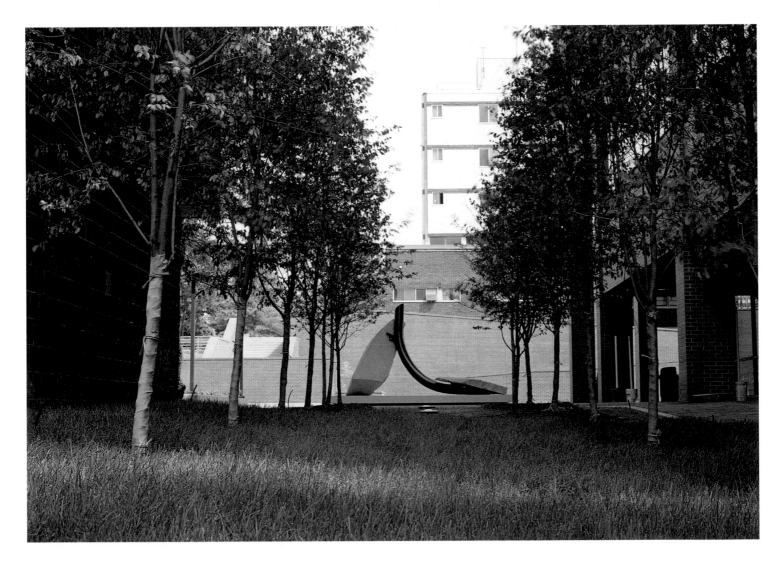

Broadreach, 1994
Granite & steel
15 x 20 x 12 ft.

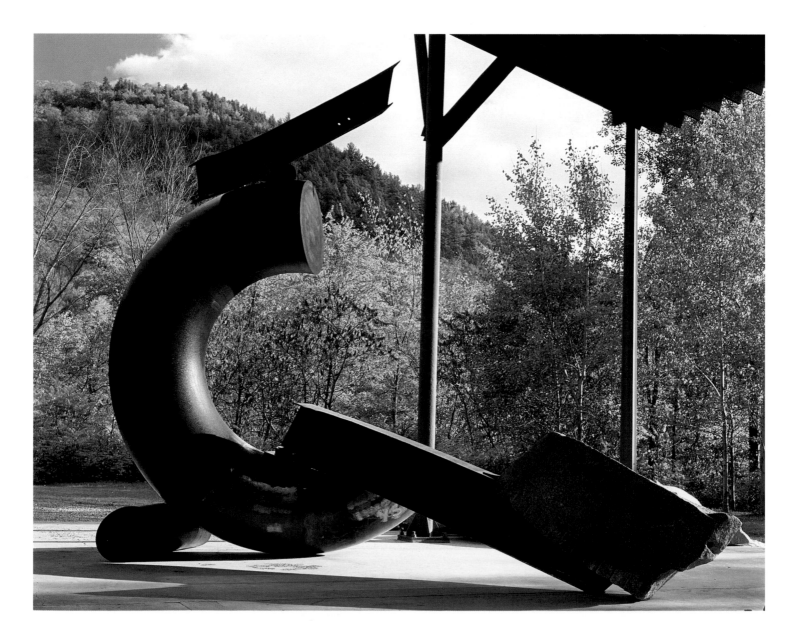

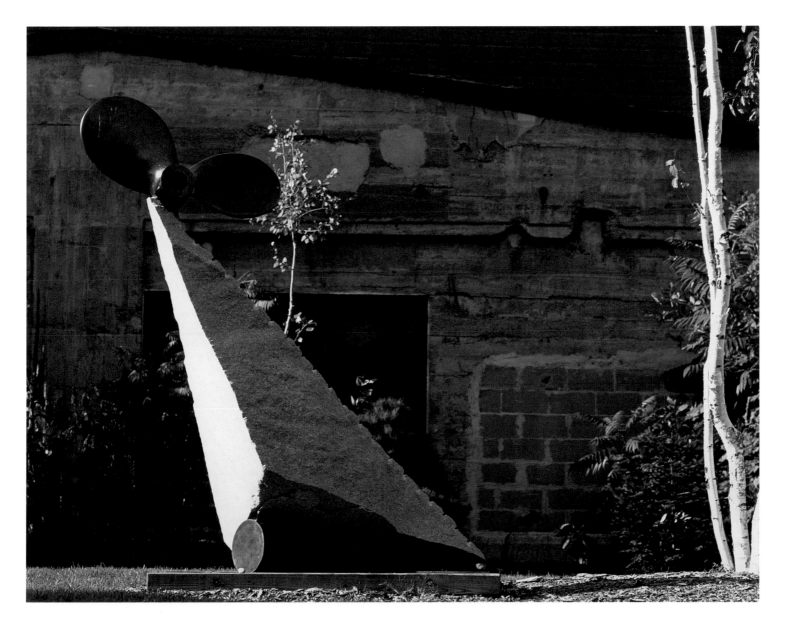

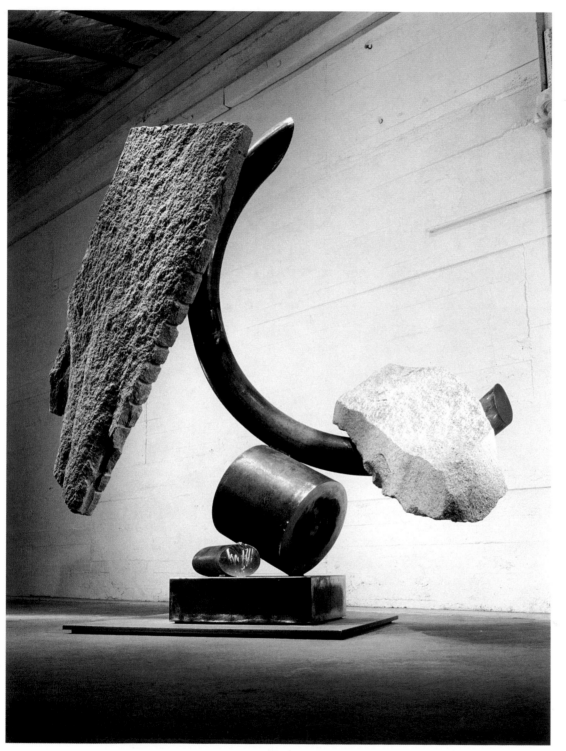

Wreath I, 1994
Granite & steel
98 x 100 x 52 in.

Chalice, 1995
Aluminum, granite & steel
128 x 50 x 36 in.

Chalice II, 1995
Aluminum, granite & steel
12 1/2 x 4 x 3 ft.

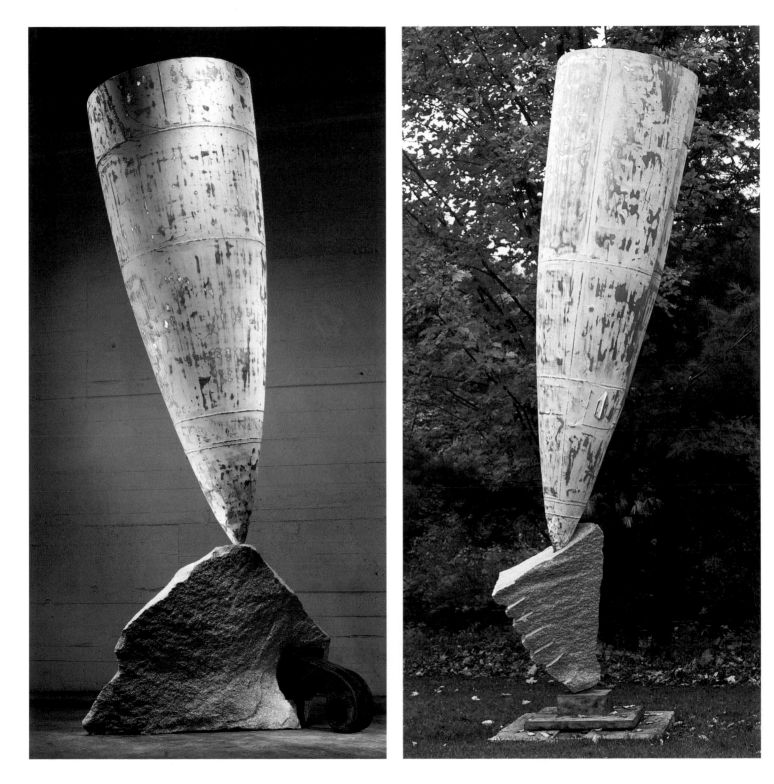

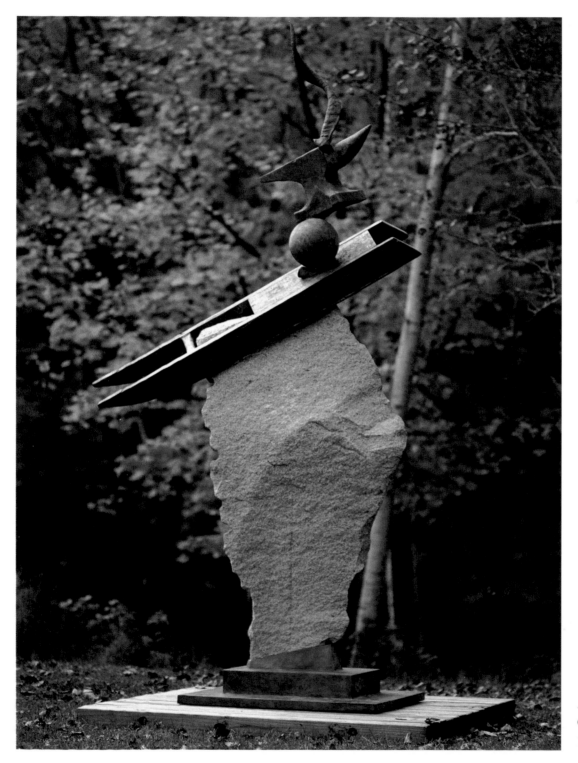

Boy's Toys II, 1996
Granite & bronze
117 x 60 x 27 in.

Labyrinth Trophy, 1996
Bronze & granite
110 x 53 x 31 in,

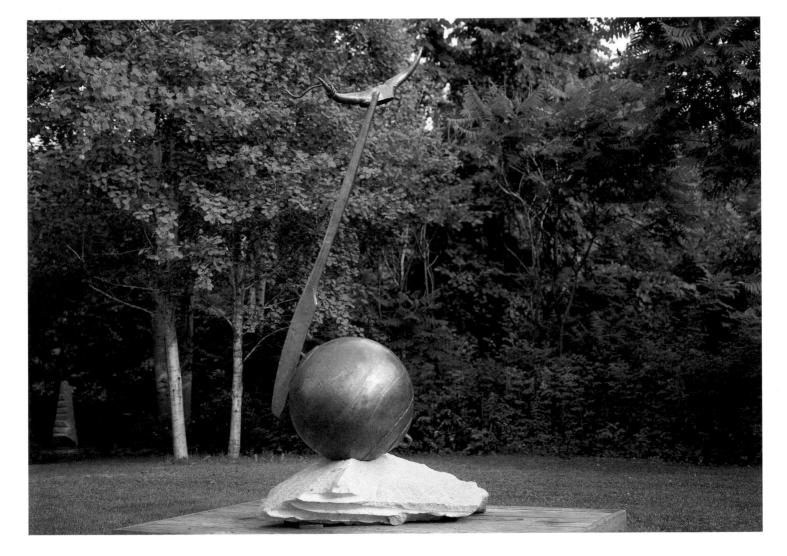

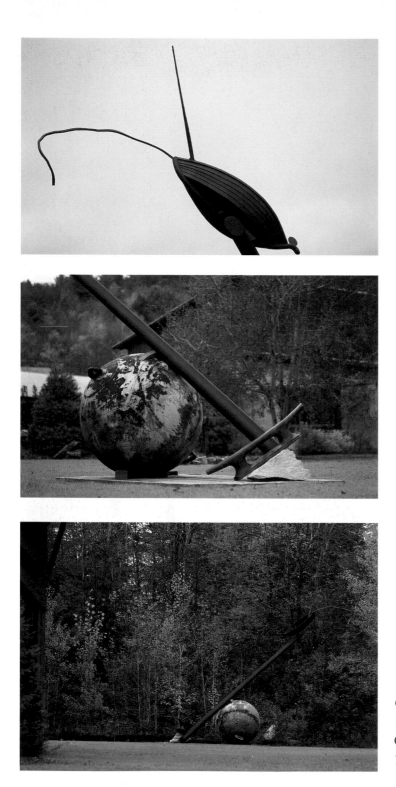

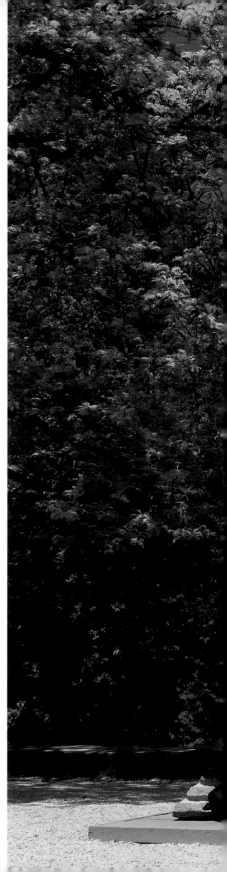

Charon's Steel Styx Passage,
1996
Granite, steel & bronze
$17^{1}/_{4}$ x 20 x 6 ft.

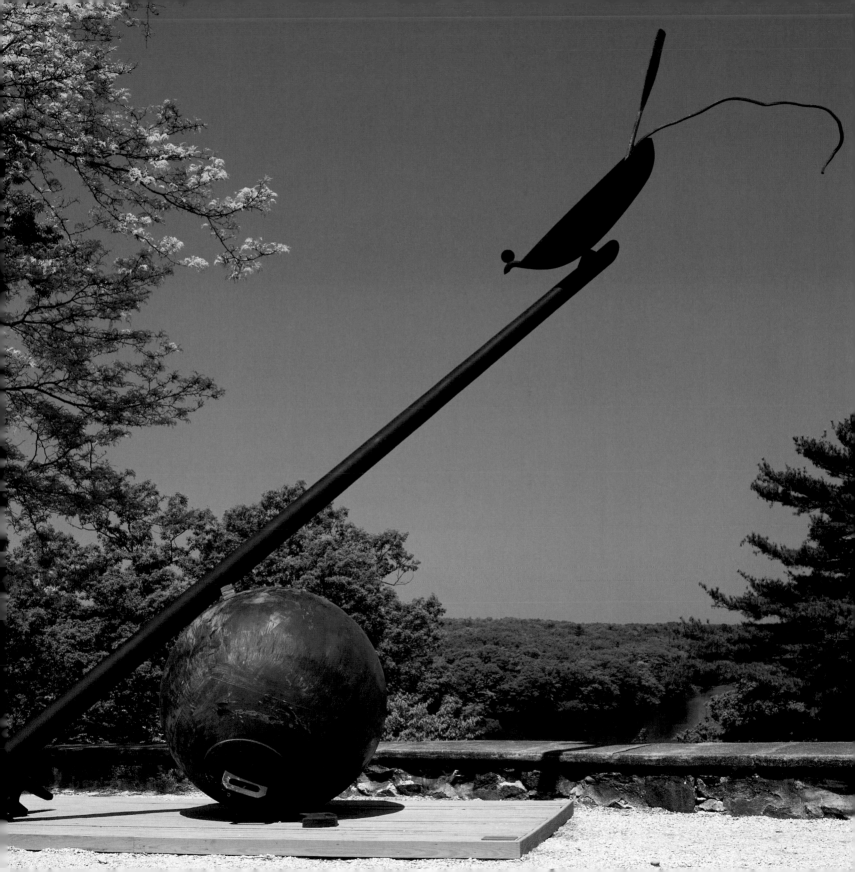

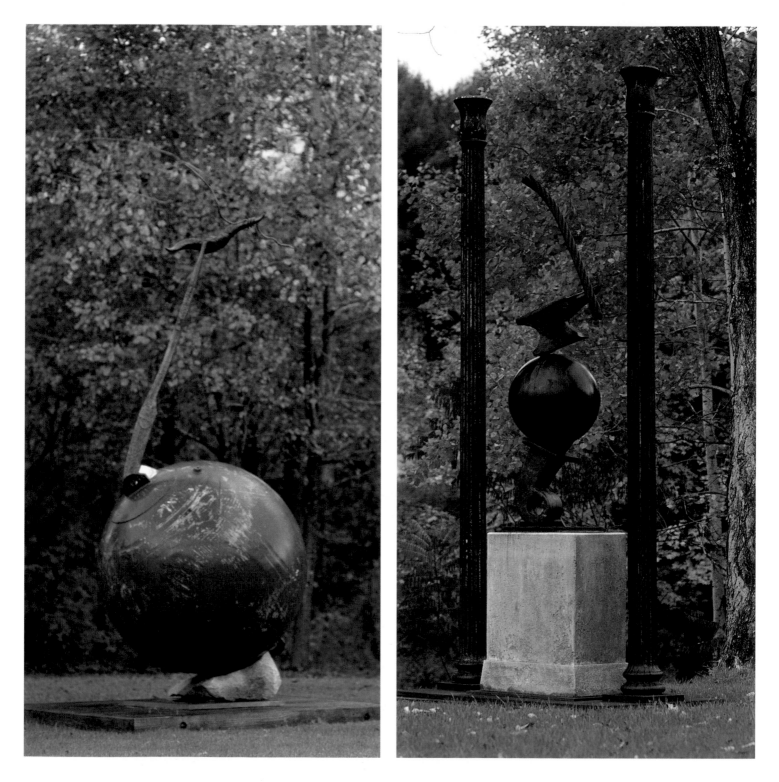

Labyrinth Trophy II, 1996
Granite, bronze & steel
12¹/₂ x 5 x 5 ft.

Cornucopia, 1997–8
Cast iron, steel & concrete
12 x 6 x 4 ft.

Buoy, 1995
Granite & steel
11 x 10 x 5 ft.

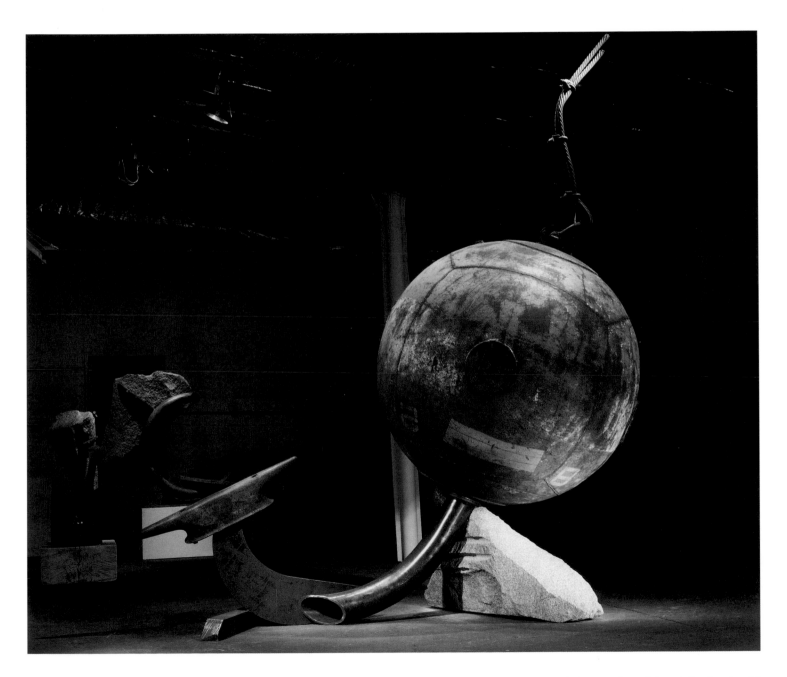

Tether (Boy's Toys), 1995
Aluminum, granite & steel
16 x 14 x 10 ft.

Atlas (High Roller), 1995
Granite & steel
126 x 72 x 42 ft.

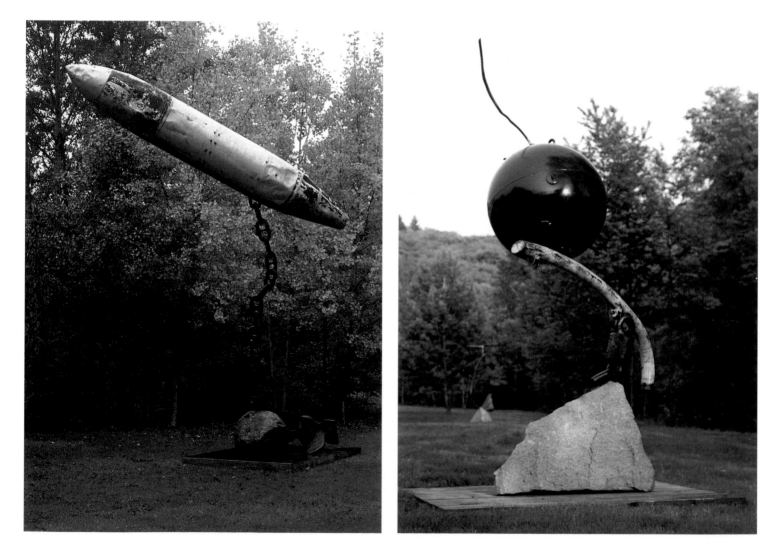

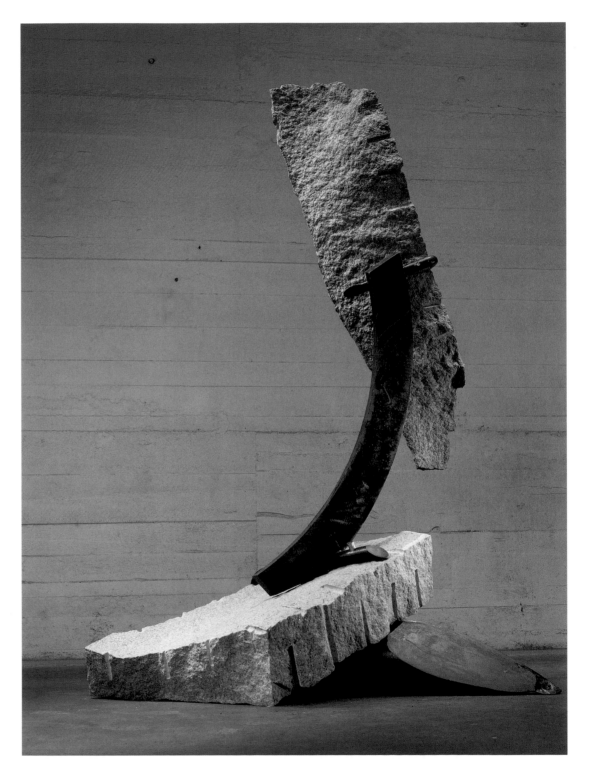

Pompadour, 1997
Granite & steel
88 x 60 x 42 in.

Pique à Terre VI, 1997
Granite & steel
58 x 106 x 50 in.

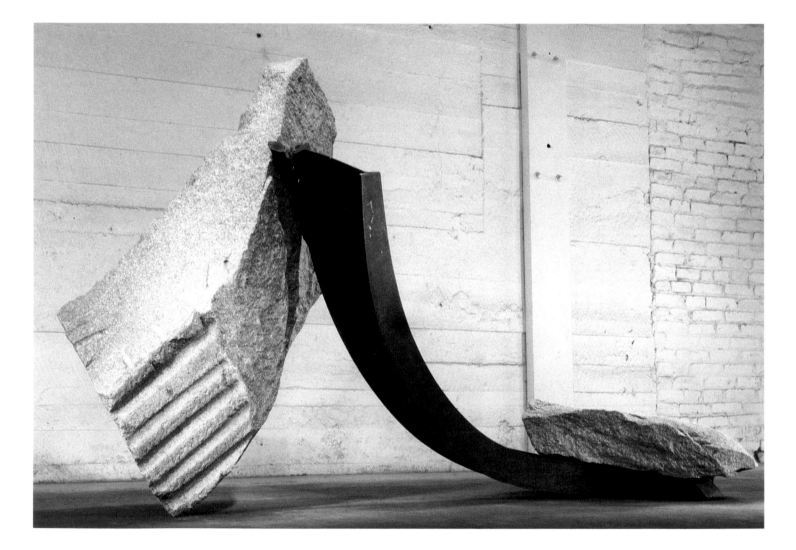

Splay, 1992
Granite & steel
64 x 134 x 56 in.

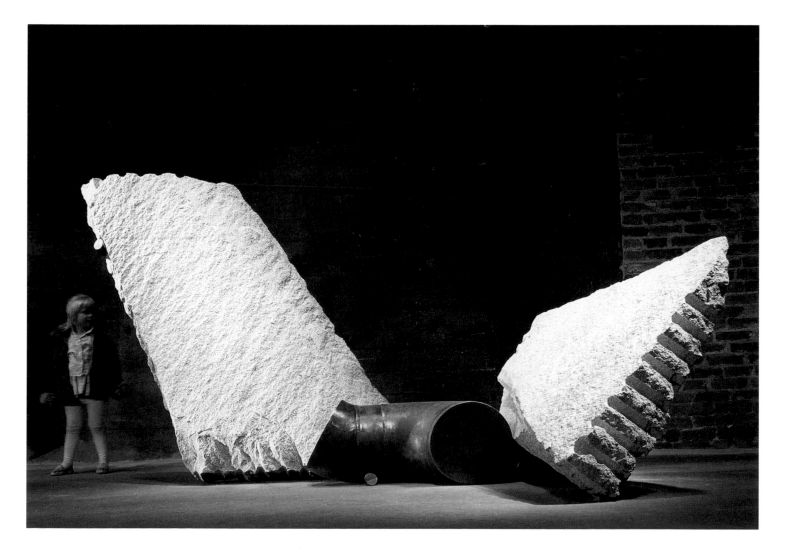

Cudgel II, 1991
Slate & steel
32 x 31 x 10 in.

Juggler V, 1996
Bronze & granite
46 x 22 x 8 in.

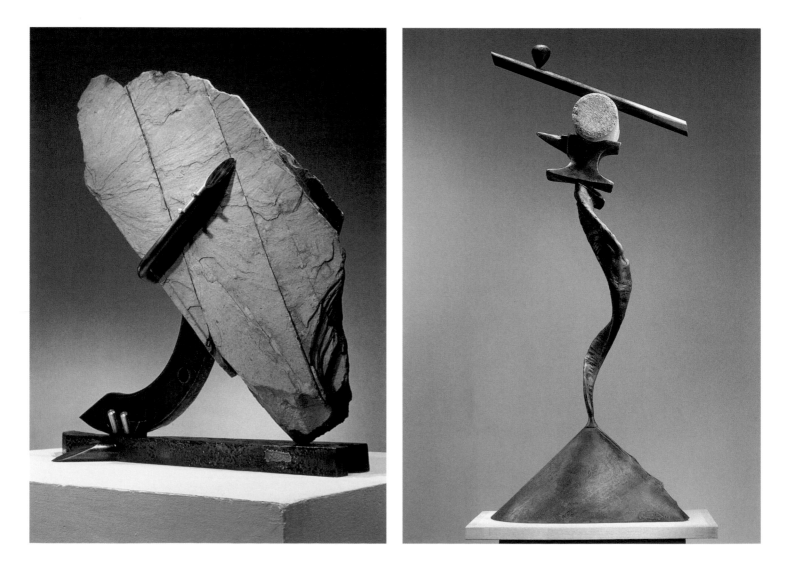

Almathea II, 1998
Granite & bronze
27 x 16 x 7 in.

Cerynean Skate, 1996
Bronze & granite
25 x 11 x 14 in.

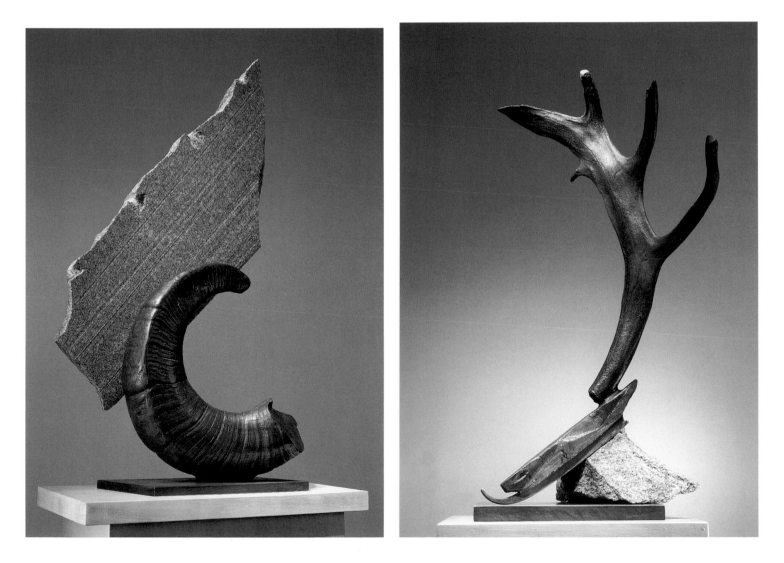

Cygnus, 1991
Granite & steel
32 x 27 x 18 in.

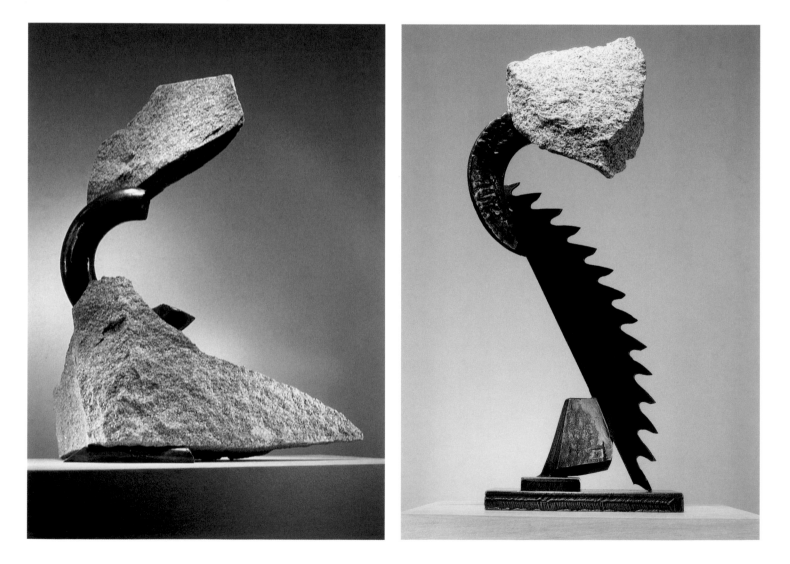

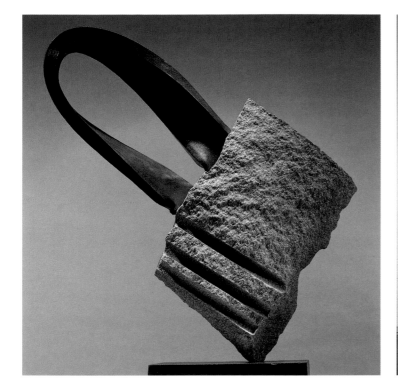

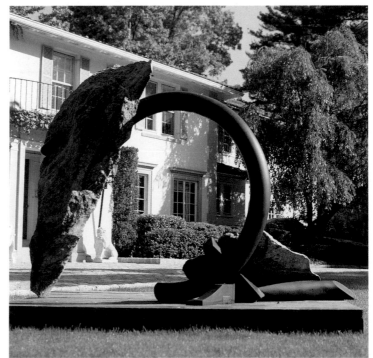

Coulter, 1991
Granite & steel
30 x 38 x 12 in.

Juggler, 1994
Green granite & bronze
98 x 80 x 32 in.

Pique à Terre VII, 1999
Granite & steel
6 x 8 x 4 ft.

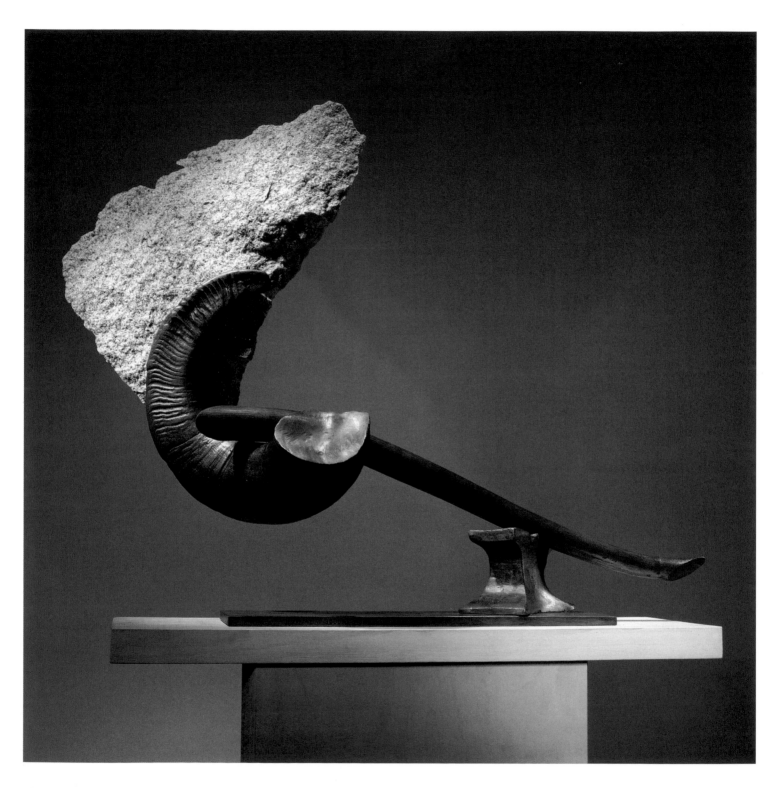

Hornhammer-Rogue, 1998
Bronze & granite
27 x 38 x 11 in.

Slate Cudgel, 1998
Slate & steel
25 x 18 x 9 in.

Fingers, 1997
Bronze & granite
26 x 39 x 16 in.

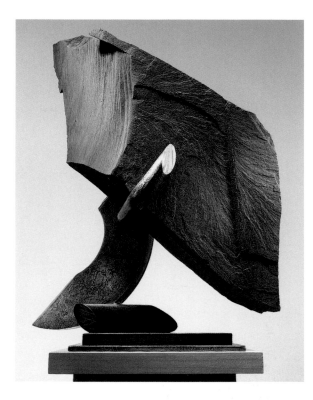

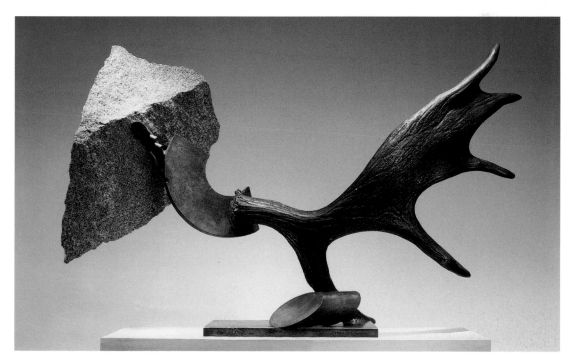

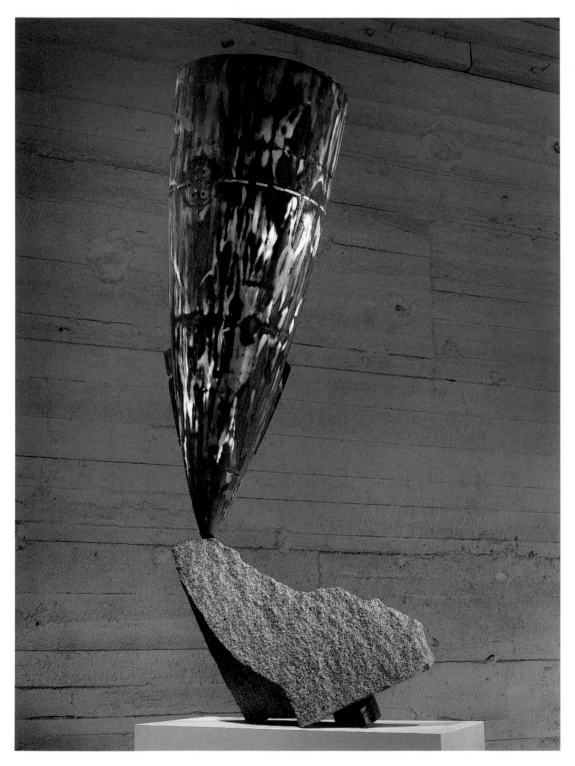

Chalice IV, 1998
Alumnium, bronze &
granite
74 x 30 x 24 in.

Ringneck, 1998
Bronze & granite
49 x 33 x 13 in.

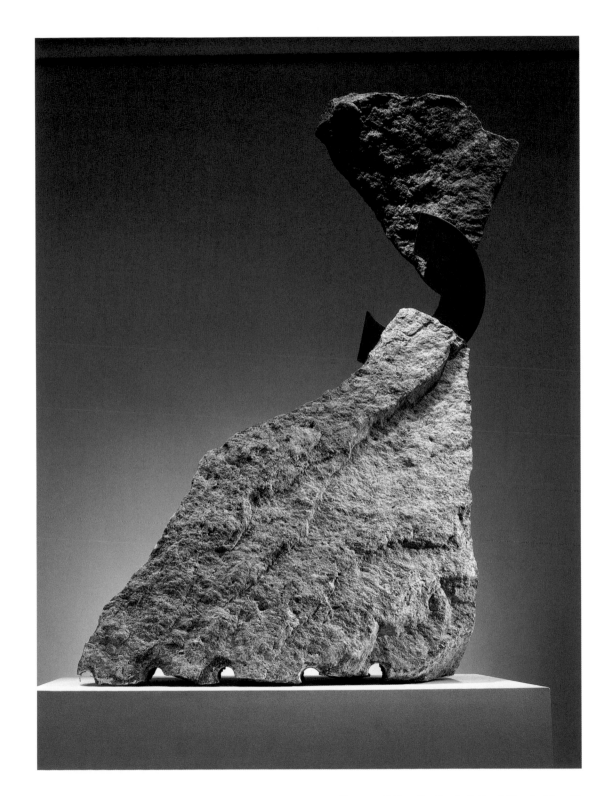

From Melanchoy to Mystery,
1985
Granite & steel
38 x 50 x 16 in.

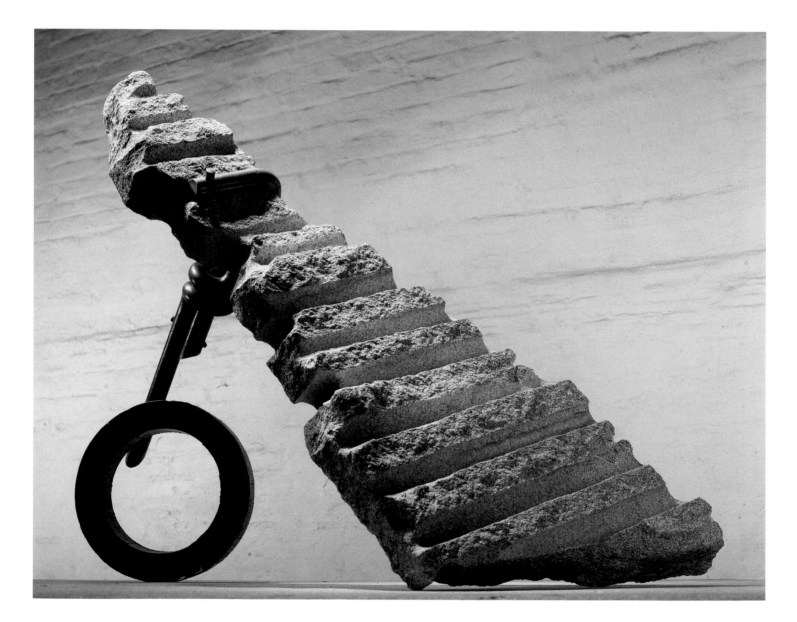

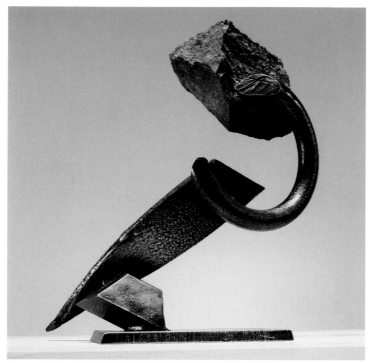

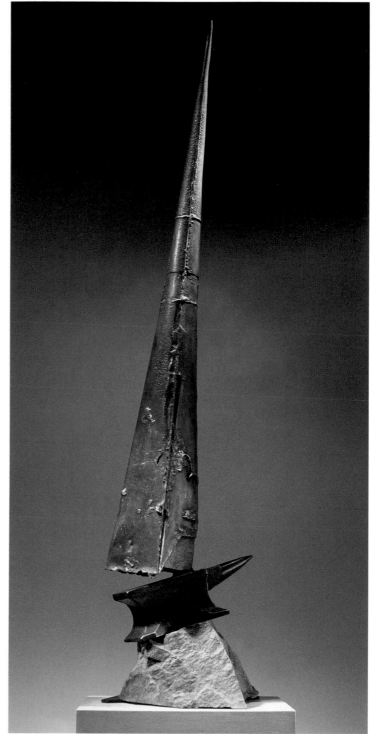

Blade, 1998
Granite & steel
11 x 11 x 5 in.

Ara V (Strike Catcher), 1999
Bronze & granite
45 x 11 x 8 in.

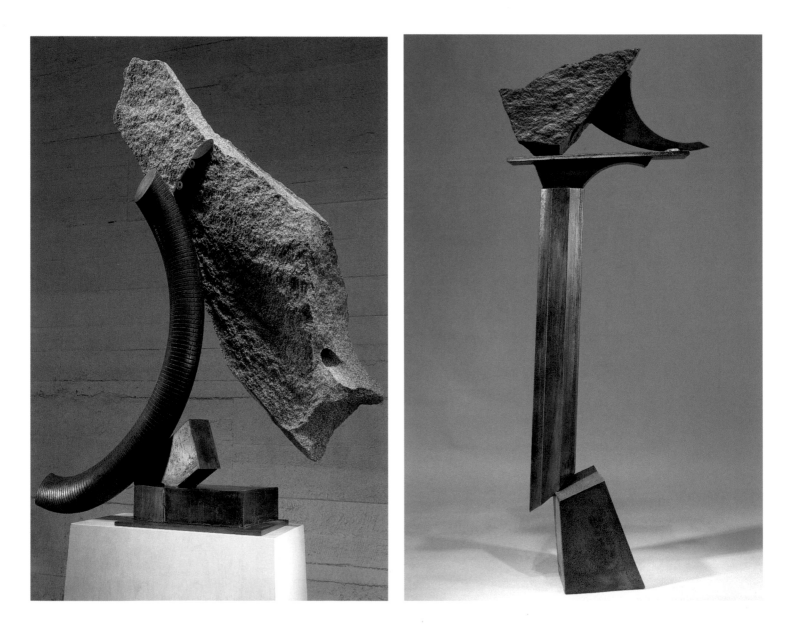

*Implement XXXVI
(Proboscis)*, 1998
Bronze & granite
52 x 49 x 14 in.

Cudgel Column, 1999
Painted granite & steel
65 x 24 x 10 in.

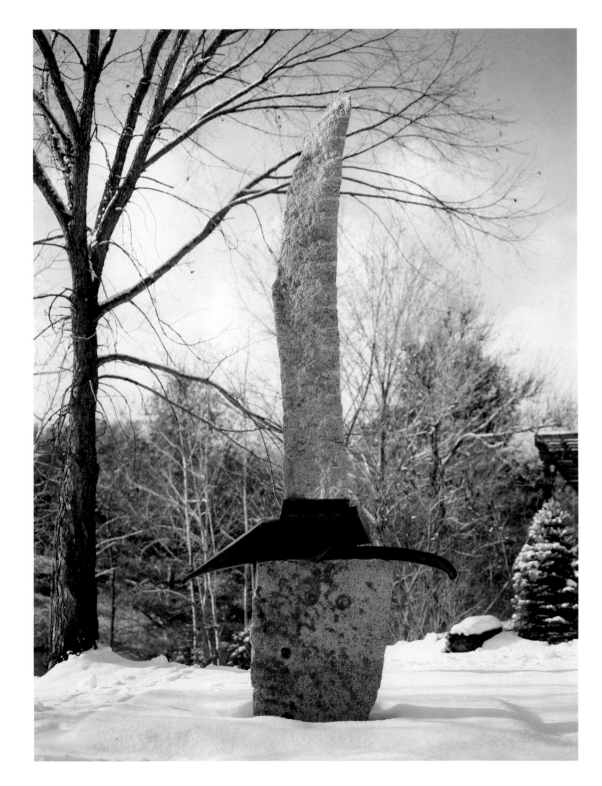

Midriff, 1997
Pink granite & bronze
12 x 5 x 2 ft.

PUBLIC ART

John Van Alstine's long involvement with placing sculpture in the outdoors has led him on a number of occasions to accept commissions for works of public art. These sculptures, chosen through competitions and sited in public places, extend the artist's concerns with the landscape by introducing site-specificity and conceptually linking terrestrial place with cosmological space.

His first public sculpture was *Trough,* 1980-82, commissioned by the city of Billings, Montana to commemorate the 100th anniversary of its founding. *Trough* consists of two mammoth leaning slabs of granite, connected and supported by linear steel members, and could be considered as the monumental culmination of the *Nature of Stone* series with its references to geologic place, time and motion. But *Trough* exists as something more. Its title and the relative positions of its stones refer directly to the sharp cut of the Yellowstone River into which Billings is wedged. The sculpture echoes the local rural sublimity of place in a downtown urban space.

Van Alstine's next commission, *Solstice Calendar,* 1985-1986, for Austin College in Sherman, Texas, introduced a

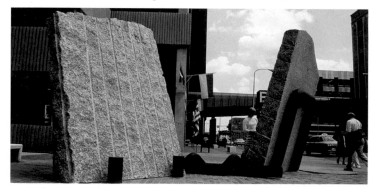

Trough, 1980-2

Solstice Calend

Granite & stainless steel
20 x 18 x 30 ft.

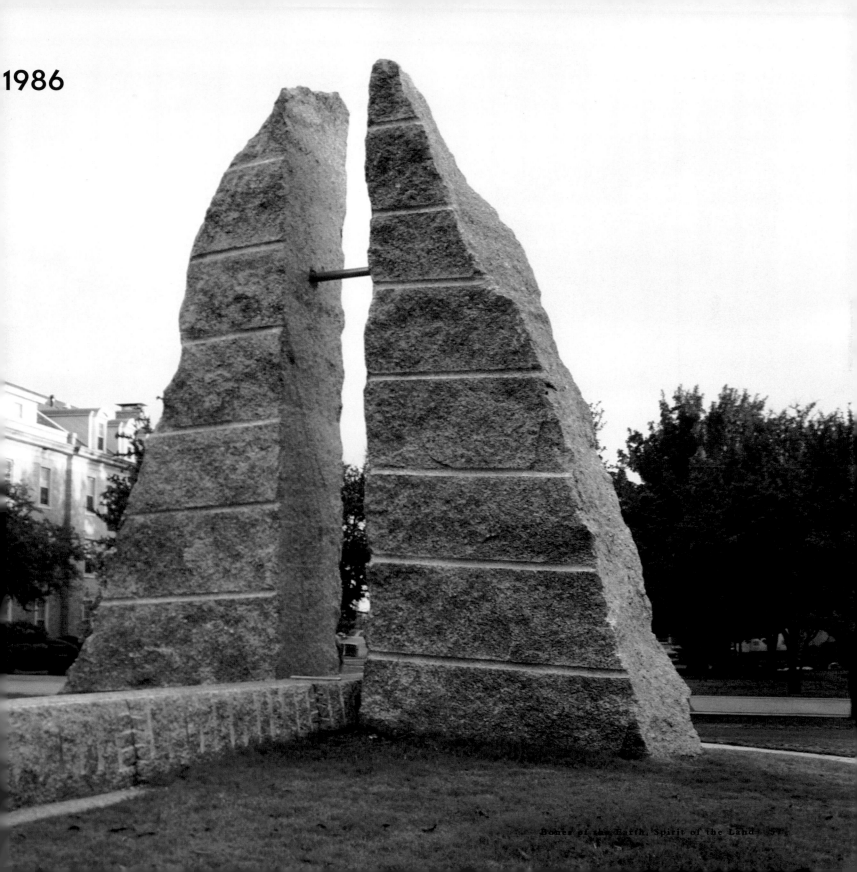

1986

Bones of the Earth, Spirit of the Land, ST.

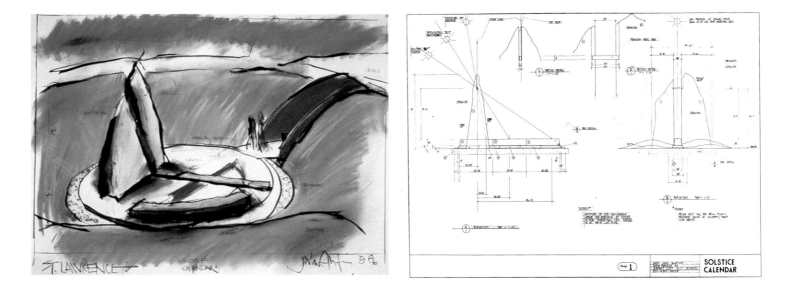

new and enduring theme to his public work: stone as a physical and conceptual mediator between earth and the heavens. *Solstice Calendar* is a pair of colossal rough Texas granite pylons that straddle a long horizontal stone member. Every day at noon the sun passes between the pylons, and a steel bar located high up between the pylons casts its shadow on the stone below. This stone is marked to indicate the annual solstices and equinox. This simple calendar was influenced by Van Alstine's study of ancient archaeoastronomic architecture in the British Isles and Meso-America, and by the work of contemporary land artists like Nancy Holt and Robert Morris who also created monumental yet basic solar calendars. *Solstice Calendar* not only locates the Austin College campus in space and time, it also bridges academic disciplines often deemed mutually exclusive by inhabiting a site directly between the school's arts and sciences buildings.

In *Sunwork,* 1989-1992, created for the Institute of Defense Analyses's Supercomputer Research Center in Bowie, Maryland, a soaring stainless steel gnomon projects from a massive chunk of earthbound granite. Here Van Alstine created another sculpture that acts as a scientific instrument, but in keeping with its high-tech site, *Sunwork* is more advanced and precise. It acts as a clock as well as a calendar. In stone pavement around the sculpture, lines mark out the hours of the day like a conventional sundial. Moreover, on a long horizontal surface, an anelemma is inscribed. This diagram, shaped like an elongated figure eight, shows the declination of the sun and equation of time for each day of the year, corrected for the precise longitude of the site. When the shadow of the tip of the gnomon strikes the anelemma, it registers noon on any given day. Van Alstine's primitive mathematical/cosmological computer helps locate this place in cultural history, as well as within the landscape and the cosmos.

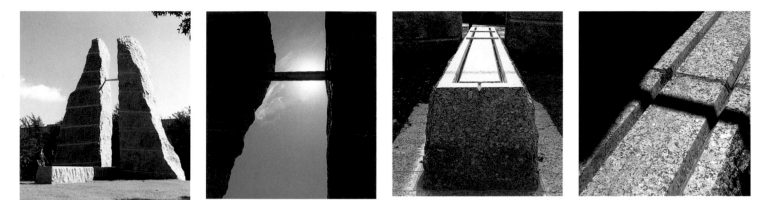

Sun position at noon Shadow at winter solstice Shadow on marking stone

Technical drawings

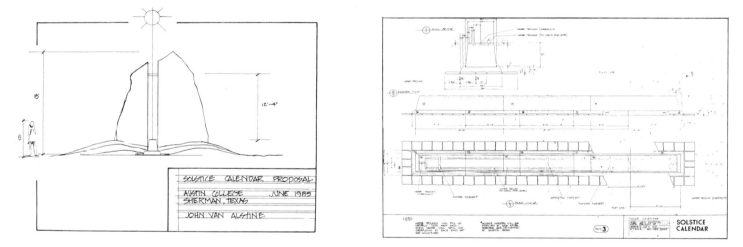

 Sunwork was followed in 1993 by *Artery Sunwork (pp. 62-63)*, in Bethesda, Maryland. This sculpture combines the formal and conceptual concerns of its two calendrical predecessors. Sited in a plaza along a heavily trafficked urban avenue, *Artery Sunwork* consists again of an anchoring stone that supports a soaring vertical element: an aspiring bronze arc surmounted by a stainless steel gnomon. The shadow of the gnomon, as it touches a precisely demarcated face of the bronze element, indicates solstices and equinox. The sculpture thus carries a consciousness of the relationships of place to earth to sky into the hustle and bustle of downtown where such grounding truths are often ignored or forgotten in a welter of streets, signs, lights, advertisements, and architecture.

<div align="right">

—Nicholas Capasso

</div>

SRC Sunwork 1991

Stainless steel & granite
12 x 30 x 45 ft.

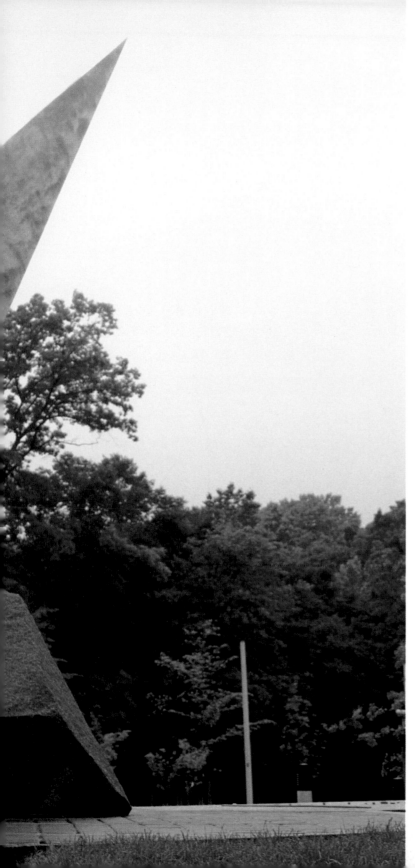

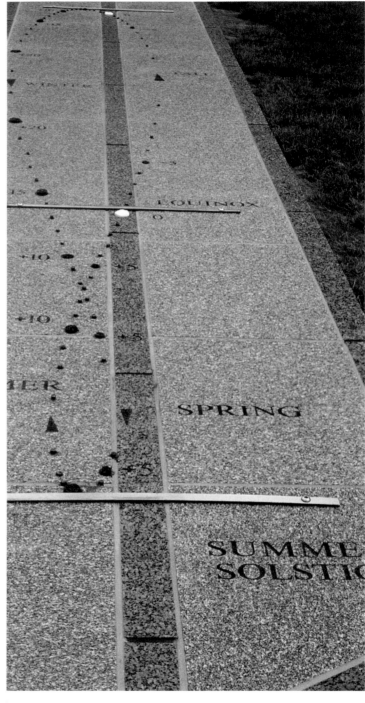

Noon line analemma

Artery Sunwork 1993

Bronze & granite
16 x 8 x 8 ft.

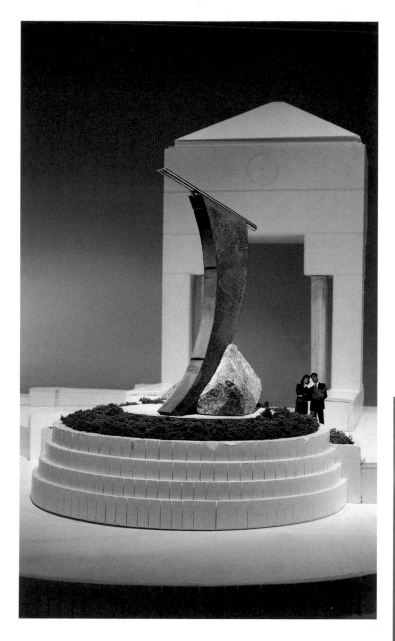

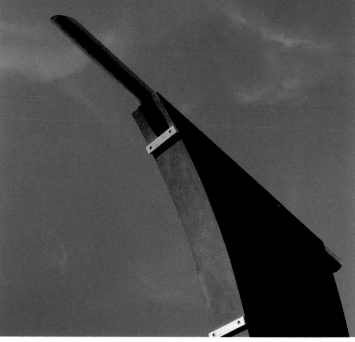

Scale model

Shadow at winter solstice

WORKS ON PAPER

Drawings

Throughout the history of art, sculptors have created drawings that relate to their three-dimensional work, and John Van Alstine is no exception. His drawings are large, richly colored pastels that are neither working drawings for sculptures in process, nor two-dimensional representations of finished works. They exist as separate and distinct works of art, informed by and informing, but not necessarily tied to, specific sculptures. Van Alstine uses drawing to further explore his interest in the potential of imagery for expression. When images occur in his sculptures - of tools, of vessels, of figures, of places – the sheer physicality of objects imposes certain limits. But in the illusionistic world of the two-dimensional, objects and images are freed from the laws of nature. Without gravity, density, weight, or friction, new and more dynamic juxtapositions and compositions are possible, and narratives become more dramatic. Potential energy explodes into kinetic energy. Objects teeter, swirl, loom, lurch, and lean. The landscape comes alive, dances, runs, leaps, and turns itself inside-out in paroxysms of joy and terror.

—*Nicholas Capasso*

House On The River, 1994
41 x 29 in.

*Passage (Red Ball with
Points),* 1990
41 x 29 in.

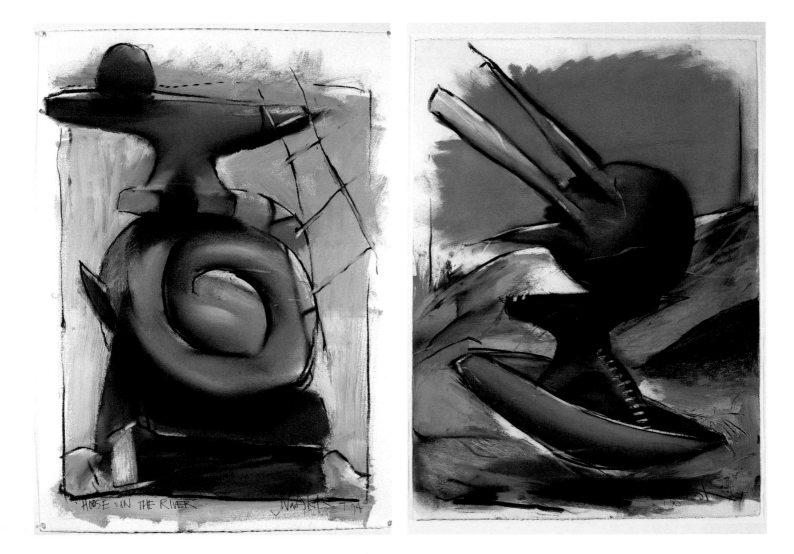

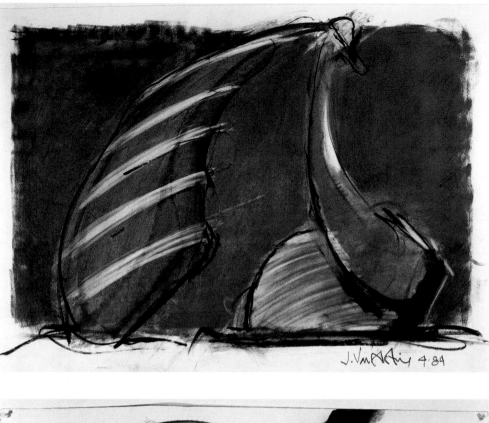

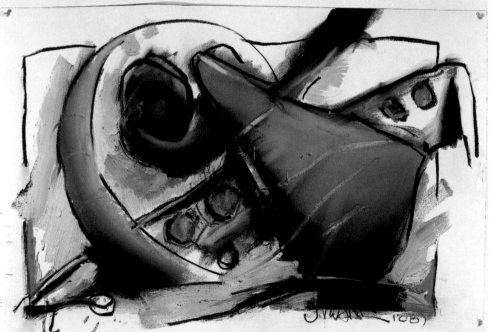

Go Round, 1989
29 x 41 in.

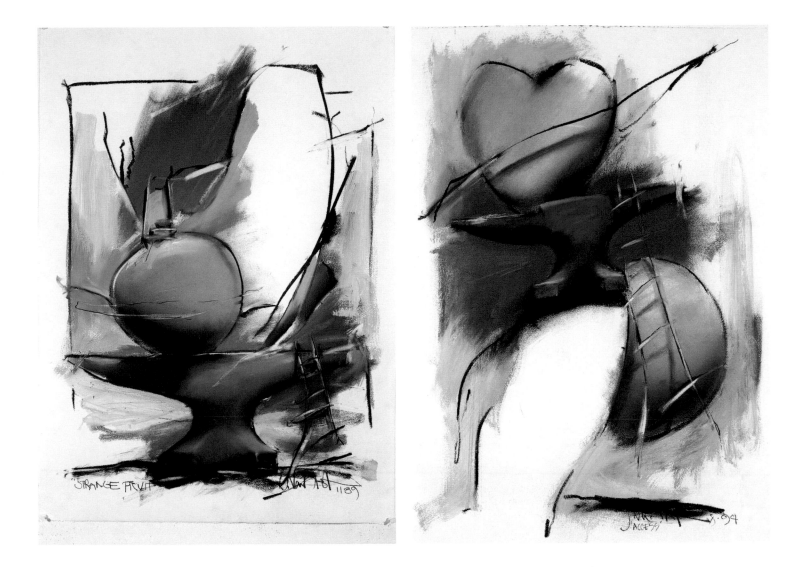

Strange Fruit, 1989
30 x 20 in.

Access, 1994
41 x 29 in.

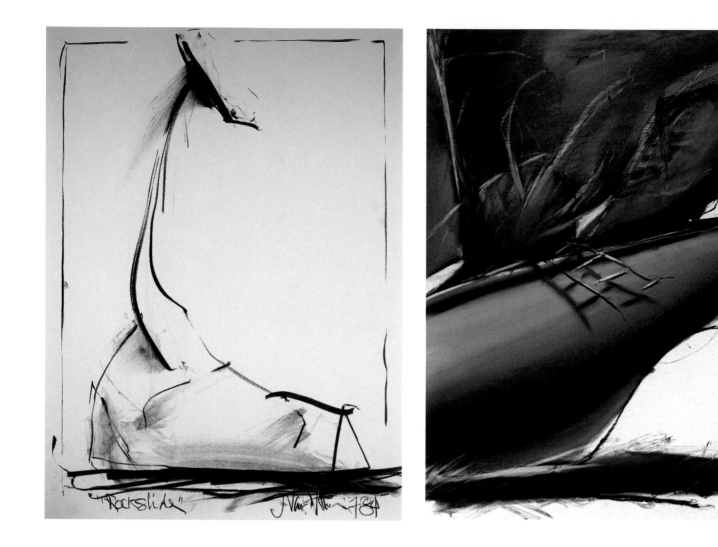

Rock Slide, 1984
30 x 20 in.

Hi Tide, 1988
41 x 29 in.

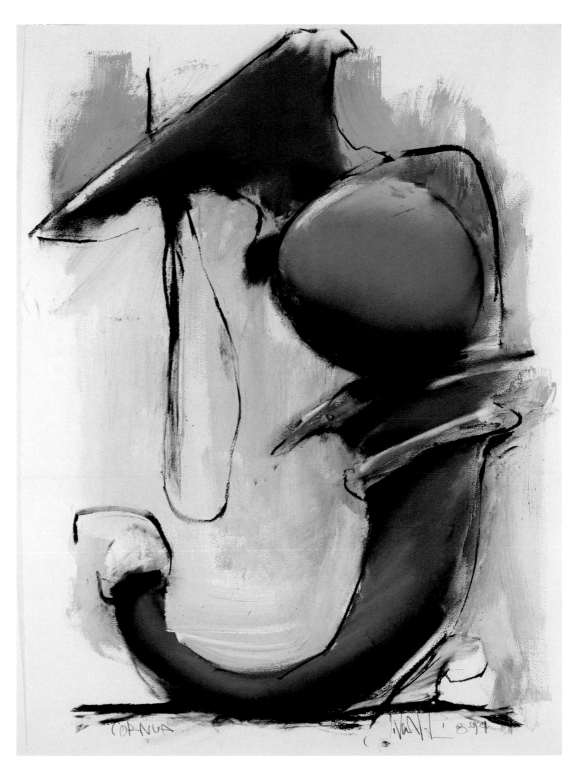

Cornua, 1994
41 x 29 in.

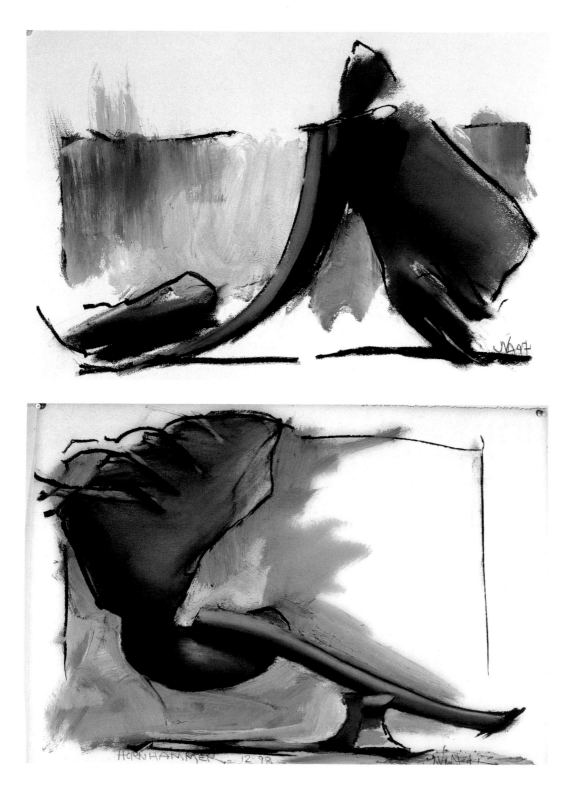

Pique VI (blue), 1997
20 x 30 in.

Hornhammer (greenhandle),
1998
22 x 30 in.

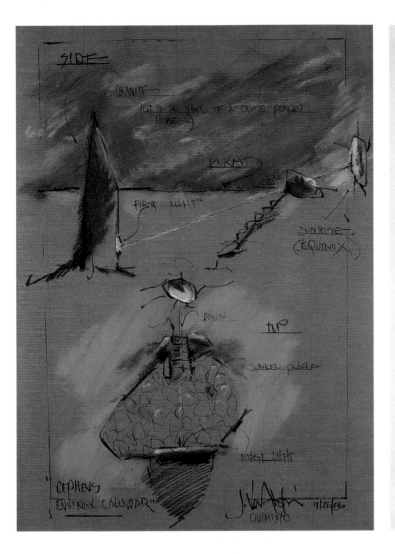

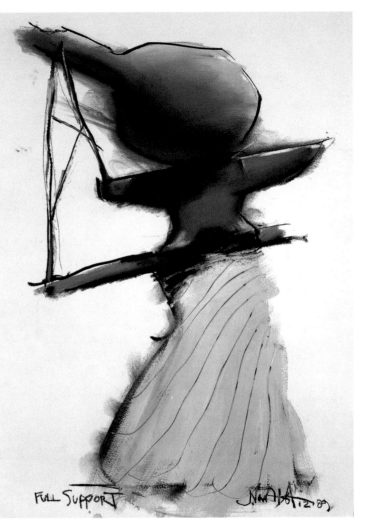

Cepheus Equinox, 1986
19 x 13 in.

Full Support, 1989
41 x 29 in.

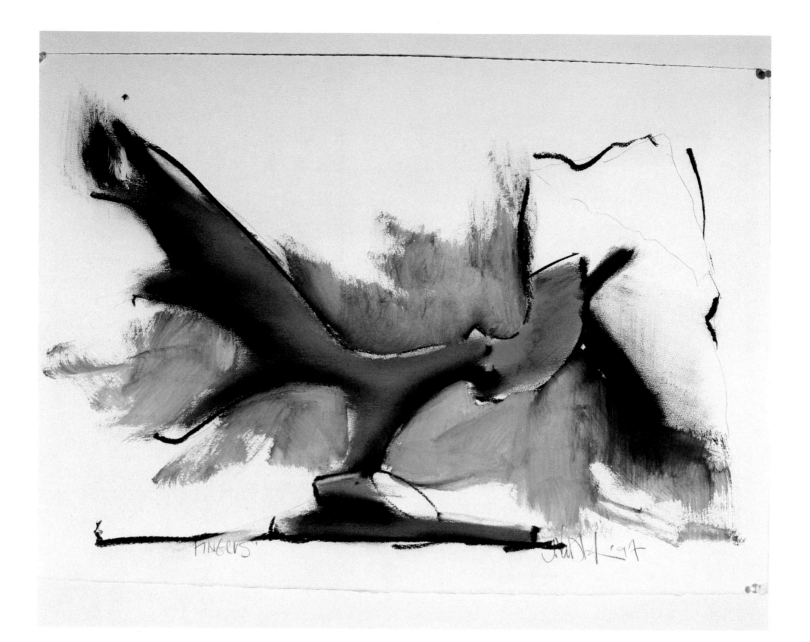

Fingers (red), 1997
20 x 30 in.

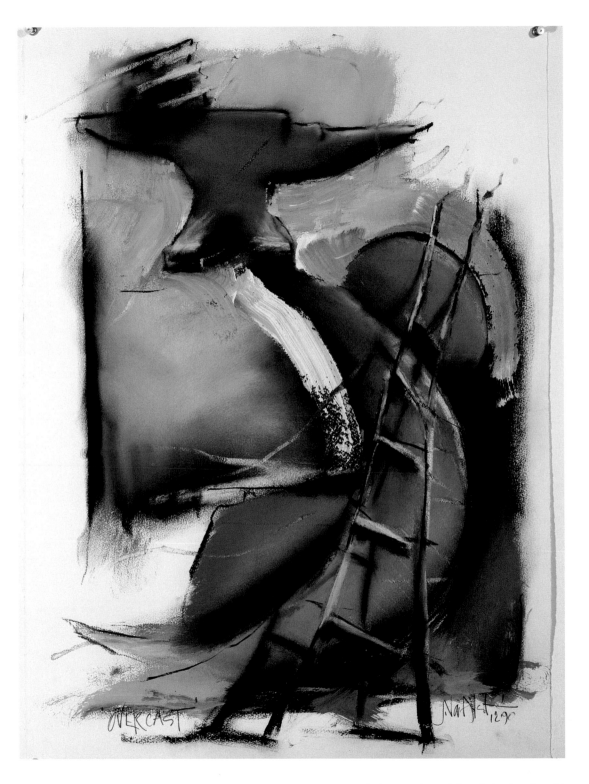

Overcast, 1990
30 x 20 in.

WORKS ON PAPER

Photographs

 Tellingly, between 1976 and 1980, when Van Alstine was experiencing and expressing the powers within the Western landscape in sculpture, he created a portfolio of photographs: the *Easel Landscapes.* These 18 x 24-inch color C-type prints are united by the presence in each image of a flat and centered sculpted steel easel that frames particular features within larger compositions. Made in and enroute to and from Wyoming, the *Easel Landscapes* provided the artist with a disciplined process for literally focusing on the landscape, and they contain some of his favorite landforms that reappear in his sculpture. As works of art in their own right, however, they deal with multiple issues germane to the intersections of photography and the landscape. Their multiple nested frames (easel, photograph, paper mat, frame) play tricks with perspective cues, and collapse or telescope perceived distances, calling into question how the eye and mind perceptually process the landscape via photography. The *Easel Landscapes* also wryly comment on how the landscape is figuratively framed by photography, experience, memory, art history, and popular culture.

—Nicholas Capasso

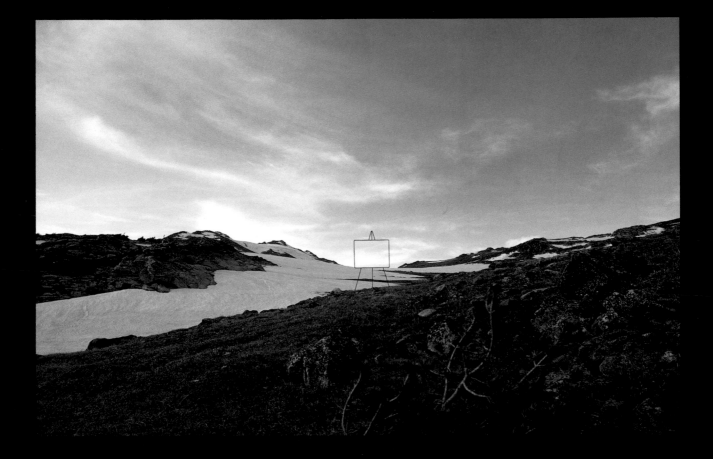

Untitled Easel Landscape

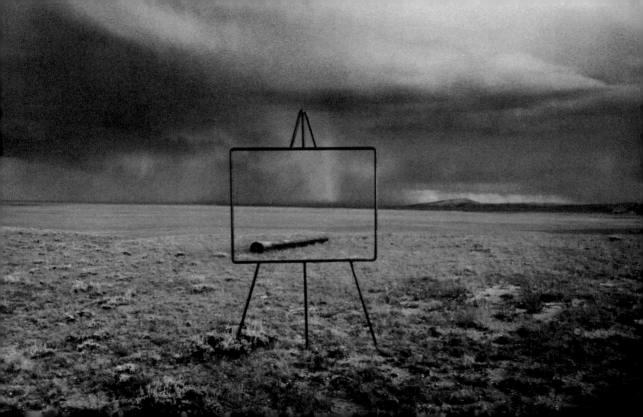

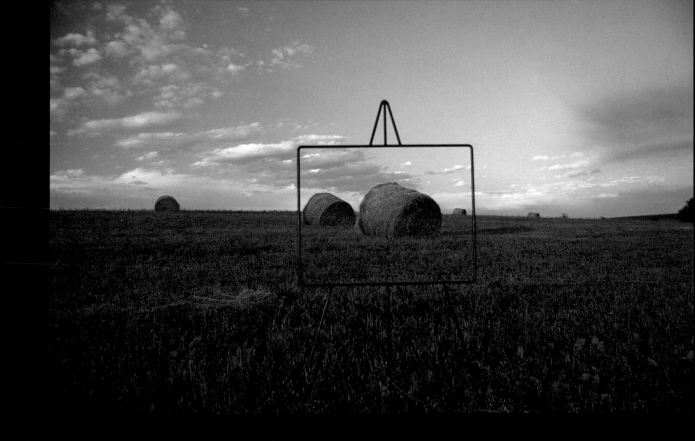

Monet Easel Landscape

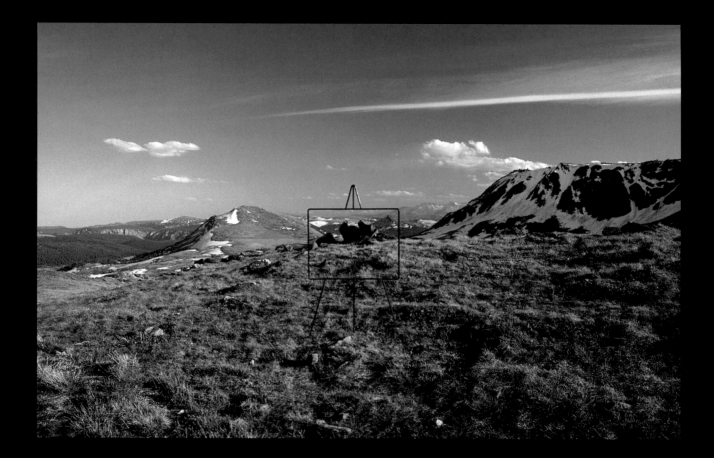

Estes Park Easel Landscape

80 John Van Alstine

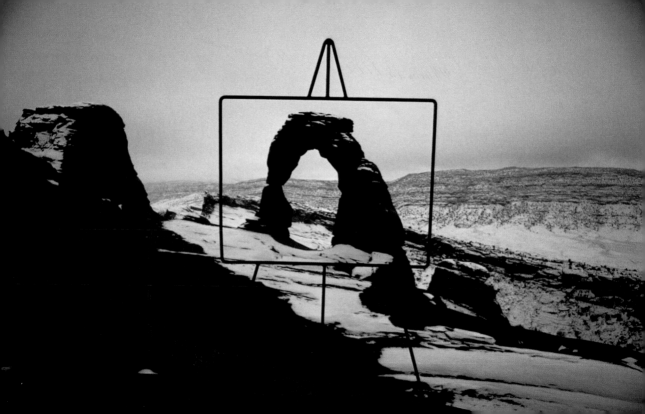

Interview

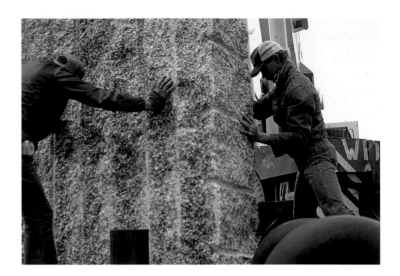

Glenn Harper: Your work seems to start with stone, even though you have most often used it in conjunction with metal.

John Van Alstine: Stone is central to my work, although I do most of the hands-on work with the metal. My first stone works were carved, but it didn't take long for the idea of smoothing out the stone, trying to make it into something that it wasn't (the Arp or Brancusi influence) to give way to the influence of artists like Noguchi where stone is accepted, even championed for what is. I grew up in upstate New York and spent a lot of time in New England. I vividly remember the rough split-granite fence posts, sidewalks, and outcroppings of granite. I'm sure this early exposure has had an impact on my interest in rough-hewn stone. But getting back to your question, like many sculptors of my generation, particularly ones that work with steel, I was/am influenced by David Smith, and a kind of American 'take charge' attitude toward the material. So, yes, I start with stone, but ultimately the work is a confluence of different materials and approaches to them. The duality of an Eastern or oriental acceptance of stone and a 20th-century industrial American 'can do' attitude toward metal is at the core of my work and is, I believe, one of the important things that distinguishes it.

GH: What led you to assemblage as a method?

JVA: Very early I realized that I wanted to work larger, so I started using multiple stones, and then introduced wood elements. I began using stone as an additive element rather than carving it in the traditional subtractive way. Some of the pieces incorporated found curbstones that were pinned together, resulting in a gestural, 3-D calligraphic statement (another oriental influence). The drilling channels in the rough stone gave the work a "quarry graphic" adding a visual cadence and revealed a history of how the material was extracted from the ground. Also, because of their cylindrical nature, the channels suggested a logical way to connect the stone via solid round bar

John Van Alstine installing
Through, 1982

Boundry, 1976
Stone & steel

which, in the early sculpture, appeared as sort of large staples.

Soon, however, I realized that I wasn't really using the full expressive potential of the materials. If the work was about assemblage and the nature of the materials, I felt I needed to create a situation where each material revealed essential intrinsic characteristics. In these early works the steel could have just as well been binder's twine or rope for example, it wasn't essential that it be steel. So, I eliminated the wood and started taking greater advantage of the structural capabilities of the materials, creating systems of interlocking steel bar to control and to hold the stone. Pieces like *Boundary*, 1976, developed where the granite is literally "bound" by the steel in such a way that the four stones rest on their edges with an opening underneath. To assemble the work the stones are propped up and the formed steel rod is wrapped around them, then the blocks are kicked out and the whole piece settles into a bound position. Because of the tremendous gravitational and real internal energy involved, these works were virtually "loaded" or "set" much like a mousetrap. In fact, one thing exciting about this series was that I felt I was creating very "realistic" sculpture precisely because of the real energy involved, much more than, say, traditional sculpture or painting, which rely on illusion.

Other pieces such as *Crimp*, 1976 and *Torque I*, 1976 (p. 14), developed with the weight of the stone applying the energy to "crimp" or "torque" the bars together and actually providing the glue that held the works together. Each element and its positioning was a necessary one. The slightest change in the structure could be enough for its collapse. I wanted the works to have a sense of arrested motion and be kind of a static energy event. A large part of the content of this series focuses on the idea of assemblage and I needed the work to speak directly to that; it is assemblage about assemblage, sculpture about sculpture.

GH: The relation of your work to landscape seems to have a lot to do with the tension of human effort in the

Near Laramie, Wyoming

landscape, rather than a "pure" landscape, it's not Frederick Church, it's the farmer at work in the landscape.

JVA: I am not interested in landscape as an illusion. Because I'm a hands-on person for most of my works, I relate to things at a scale which can be humanly manipulated. I'm not personally interested in doing earthworks like Michael Heizer, with a giant bulldozer, but I do respond to the idea of the farmer taking a plow and cutting lines in the field. I relate to what is done in or to the field, but I am even more interested in the tools/implements used and their functional and conceptual relationship to the landscape.

GH: How did the landscape in the West affect your materials and your ideas?

JVA: In the fall of 1976 I moved to Laramie to accept a teaching position at the University of Wyoming. Up until then I had lived in the East, where the landscape is generally obscured by vegetation. The Western landscape was stripped bare, revealing the geology and conveying vast amounts of information about its formation and history. Considering that stone was my primary material, all of this had a profound impact. There was a different and empowering sense of scale— I was taken by the towering buttes and unbelievable natural arches which ultimately led to the *Totem* and *Arch* series that I still work on to this day. I was struck by the overwhelming amount of sedimentary stone, created by millions of years of layering. Sparked by Jackie Ferrara's 1970s stacked plywood pieces and the way they were informed by the layers in that material, I started building works that incorporated stacked Colorado flagstone to echo or reiterate the nature of the material and how it came into existence. Coupling the "interlocking" steel bar vocabulary that I had developed with massive stacked columns, I created structural systems that were not held together by welds, but rather by the controlled and channeled gravitational energy of the tremendous stone piles. In theory, the higher the stack the greater the energy and the stronger the "glue" which held them together. Some works in the series were left open on the top suggesting the pile could continue indefi-

Tripod with Umbilical, 1982
Yellow granite & steel
90 x 72 x 80 in.

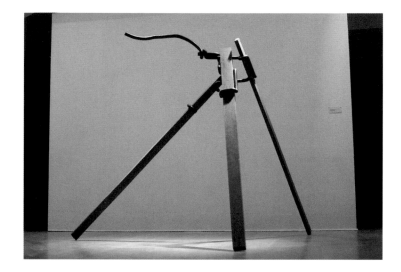

nitely, recalling and paying homage to Brancusi's *Endless Column*. They were titled *Stone Pile I, Stone Pile II* and so on and like earlier works *Crimp* and *Torque*, the title was both a noun and a verb, indicating that the sculpture was as much an action as an object. The more I worked on this series the more I realized how much a fundamental human activity stacking is, it is a common, universal form of "sculpture". We stack to store, to move, to count, to take inventory, to build, etc. I began to notice innumerable ways, different shapes and forms, with lumber, fire-wood, stone, hay, many types of architecture, etc., all of which further informed and influenced new works in the series.

GH: *Tripod* with *Umbilical*, 1982, is a work that marked a shift, a breakthrough indicated by that line trailing off into the air.

JVA: I moved back east to Washington, DC, late in 1980 and for a while continued to work with sedimentary stones. Soon the influences of the urban landscape and the feeling that I had exhausted the very tight, formulated, interlocking, no-frills work led me to consider other options. The *Tripod* piece was almost like my flag going up to say, "I've done this, and I'm beginning to break away." The "umbilical" or squiggly steel bar was a sort of lifeline back to where I had been and forward to something else. The next important piece, *In the Clear*, 1982 (p. 13), combined this continuing need to break away with a timely discovery of a supply of crushed I-beams, pipes, and tubes, as part of a subway construction yard just outside the city. The piece incorporates a physical suggestion of vegetation and in one way it is a landscape reference, "in a clearing," but at the same time it's about "breaking clear" from that self-imposed restriction of only making work that was structurally driven.

GH: The found objects in the more recent works are ultimately as much about landscape—urban landscape—as are the pieces that reflect the Western landscape.

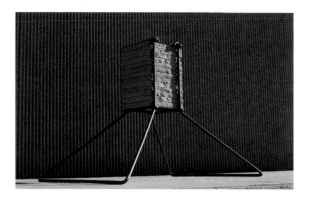

Stone Pile II, 1978
Stone & steel
60 x 82 x 62 in.

JVA: In order to be closer to New York I moved from D.C. to Jersey City in 1983. The industrial and marine salvage landscapes there have had a major impact on my work both as a source of found objects such as anchors, chain, buoys, cleats, and as a place with unique and compelling characteristics. Works like *Link I* (p. 26) and *II*, I feel, are sentinel pieces, and speak directly to one of the core aspects of my work—the marriage of very different materials—creating a meaningful amalgam from natural and human-made things. The large piece of chain at the center of these works, literally linking the elements, is called a "pelican clip," because of its shape and its function of clipping large pieces of chain together. It is a connector, a kind of "super link," and that fact, along with its position in the work, intensifies and underscores the central idea of union.

The calming characteristic of marine salvage yards, basically in the center of busy urban environments, has always surprised and attracted me. Perhaps because it's a transition zone from the intensity of the city to the serenity of the sea. In any case, it has inspired many works. *Tether (Boys' Toys)*, 1996 (p. 40), for example, uses a 1,500 pound anchor to hold aloft a large piece of animated welded chain and a wafting torpedo form. It generates a passive, almost weightless feeling of being viewed from underwater. While I was working on it I was reminded of the magic I felt as a kid when I first saw farmers' mailboxes along a county road floating atop welded chain. The fact that the piece simultaneously conveys a sense of "folksy" and "marine urban" attracted me. As the piece developed further it began to suggest the model airplanes I built as a kid, thus implying toys. The floating cigar/missile/penis form seemed to demand that it reference "boys' toys", which added layers of symbolism and association. When completed, I felt it pitted playful innocence against sinister, rural against urban, which created a very interesting tension.

I have several works that use large ocean buoys found in these yards, in fact one is titled *Buoy*, 1995 (p. 39). It has occurred to me that the act of making art is like dropping buoys as you bob along in your "stream" of creativity, leaving floating reminders of where you've been. *Buoy* attempts to formalize and convey this idea.

GH: So the found objects link the stone drawn from the landscape with urban, rural, and industrial environments. You mentioned tools, and a lot of the found objects seem to have to do with working, with effort or fabrication.

Astraea's Beam, 1991
Bronze & granite
55 x 72 x 18 in.

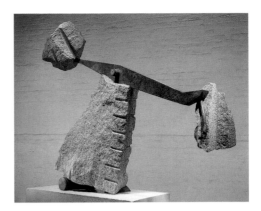

JVA: As a sculptor I've always been interested in tools, implements, and instruments. I see them as extensions of the artists' hand, important allies. I am also drawn to their raw, efficient beauty of form dictated by function. I am certainly not unique in using tools. David Smith, Jim Dine, Picasso, and many others have staked out some very impressive territory. But I feel I have something to add based on my unique experiences and perspective.

Having grown up in New England for example, it is hard not to be impressed by its beautiful stonewalls both in terms of the way they knit together the landscape (they are the bones) and by the sheer pre-industrial effort it took to form them. In *Sledge,* 1992 (p. 28), I wanted to pay homage to that effort and beauty by creating a piece based on the "stone boats" or "sledges" that farmers used to use to drag stones from their field to the edges, to build those walls. In the piece the bed of the sled and its cargo were designed to be one in the same, the single large flat piece of granite acts simultaneously as both. There is something important about this union. Perhaps it's because it presents a "oneness" with the material, tool, intent, and final product.

Many of my works incorporate anvils, either real or cast. Anvils have the shape suggestive of a boat or vessel which implies journey which interests me. But further, as a metal worker, it is the place where I physically and conceptually forge things together. There is an art spirit that comes off the anvil. It's almost like an altar. I've titled many of these pieces *Ara* (p. 20), which is Latin for altar. Also, to me the anvil is the quintessential heavy object, and to get it up in the air creates a wonderful sense of tension.

I use references to tillers, both in the sense of the agricultural implement and tiller as a navigational devise. The idea of an instrument that aids one in carrying out decisions, to chart a course, is significant. It can be seen as a metaphor for the very thing that distinguishes us from other beings on the planet and provides a wonderful creative vehicle. The scale or balance beam is a tool/idea that provides another vehicle, in part because much of my work is concerned with physical balance. One piece in a series based on the scale is *Astraea's Beam,* 1991— Astraea being the goddess of justice. Its unnatural positioning addresses the question of the equality in our contemporary judicial system.

GH: There are other seagoing references, especially vessels.

JVA: The ship or vessel is a common and perhaps universal metaphor for passage used throughout art and literature. Many of the found objects that I was attracted to suggested boat forms, and in an attempt to broaden my work, I started to incorporate them. Actually the vessels in my work started out first as containers influenced by my background as a potter. I put myself through graduate school working as a production potter and playing off the idea of a functional vessel is in my vocabulary. The *Chalice* (p. 33) series, for example, starts with the suggestion of function, but because of their scale (6-13 feet), the unusual combination of materials and unnerving positioning of elements, moves them beyond function and transforms all the elements including the open-ended aluminum aeronautical fuselage, into something akin to spirited "cups of life".

GH: In the *Chalice* series, did you polish the aluminum to get the color?

JVA: Sort of. I took a belt sander and worked through the applied paint, revealing different layers of color, and in some places sanded down to the aluminum. In a way, it's a lot like my drawings, where I'll add color, build up layers of pastel, charcoal, and then go back with an eraser, digging through to reveal some of what's underneath. For me drawing is a release. It is similar to working with clay—putting material on, taking it off, until an interesting balance is reached. Like clay, the drawings respond to the touch—stone or steel demand machine tools in order to be manipulated. I do drawings all the time, the spontaneity and easy manipulation of the medium is a great counterpoint to the often long, deliberate task of building a sculpture. Sometimes the drawings are fantasy pieces used to develop ideas that may or may not be impossible to translate to 3-D. Others are of finished work, kind of a 2-D and often very colorful interpretation.

GH: Your color photographs seem to deal directly with landscape—do they relate to your sculpture?

JVA: The photographic *Easel Landscape Series*, 1978-80 (pp.74-81), was a direct spin-off from the sculpture. In fact the six-foot steel easel central in all the photographs was originally made for an indoor piece where I was exploring the idea of framing. For fun I set it up outside and was amazed what happened, there was an immediate connection to Magritte and his paintings of the easel against a wall suggesting a window, the ones where there is a painting of a painting, the illusion of an illusion. I felt there was potential for something in all of that, and I began taking the easel with me when I traveled. It actually became a great excuse to get out into that wonderful landscape and feel like I was working! I viewed the photographs as documents of sculptural installations—the placement of the steel easel in specific landscapes. They were about sentiment, perception, the convention of the frame, our inability to contain and compartmentalize that incredibly expansive landscape. There were some of haystacks–*Monet Easel Landscapes* (p. 77); there were *Abstract Easel Landscapes* (p. 79). I photographed in places like the famous Artist's Point in Yellowstone Park, conjuring the ghosts of Bierstadt and Moran. It was a very fun project inspired and propelled by that fantastic landscape. Once I moved East, the urge to continue evaporated.

GH: How do you plan the pieces? Do you select the materials first or match the materials to an idea?

JVA: I seldom work from a predetermined plan or drawing. I have a big reservoir of found objects: stone, steel, and other non-metallic objects. When I travel, I try to collect interesting things that I think someday, somehow might inspire a piece. In the studio I do a lot of experimenting, like an alchemist putting stuff together until something happens. Sometimes it works and sometimes it doesn't, you keep at it until you feel like you've got something. I like to use a fishing analogy: you work hard to get a "keeper", sometimes you have to "throw it back." The fun part is bringing disparate elements together and never quite knowing where it's going to lead. Usually the piece reveals itself as it's developing, in terms of what the title might be or ultimately what it is.

GH: There is a figural aspect to your work in that (except for the large public pieces) it's at your scale, you are in the middle of it putting it together. But there are also more explicit references to the figure.

JVA: For a long time I really didn't want to acknowledge the figure, but I came to the point where it was a conscious aspect of the work. *Reconsidering Sisyphus*, 1992 (p. 29), for example, is in a way a self portrait, of my own creative struggle. One of the ways to interpret the formal arrangement of the stone and steel in this piece is as a figure frozen in the act of prying or pushing a stone, as in the myth of Sisyphus. In a way that's what I do. I am out there literally pushing stone around aiming for this very elusive place, and once there, I start over again, with no real "end". The title arises from Camus' *Myth of Sisyphus*, where he "reconsiders" Sisyphus's labors. For the artist the creative experience is not a goal, one never just reaches the "top" and says "I'm done," but rather spins in a continual regenerative cycle where the value and reward emerge from the process. It seemed like a perfect analogy.

Some more recent pieces refer to movement of the figure, particularly the *Juggler* (p. 44) and *Pique à Terre* (p. 47) series. *Pique à Terre* is a term from classical French ballet for a pose with one toe touching the ground, the other foot firmly planted with a sweeping arm gesture. Once you are aware of the title, when you see the piece the connection is clear. I am in a sense choreographing these works, getting a heavy weight off the ground and making it dance—taking what is often seen as a negative, the fact that stone is damn heavy and a big hassle to move around, and turning it into a positive. It is this transition that helps give these pieces their magic.

GH: Do you select stones rather than have them cut?

JVA: I have a flatbed truck with a crane, and I go to the quarries or stone yards and pick the pieces, bring them back and have them around in a kind of "reservoir" to select from. Generally I look for stones that have a fresh, clean, geometric character, they seem to lend themselves best for combining with other materials. Granite works well for my current work because it is very durable and can stand up to the "abuse" I tend to put it through. I also like its subtle, inert character. It does not call too much attention to itself, is not overly "pretty." I also am attracted to the subtle sparkle of the mica that is embedded in it—split granite suggests the ephemeral sparkle seen in freshly fallen or drifted snow, yet it is such an obdurate material. I like the contrast.

GH: For the large public pieces, there is also a found-object quality in the stone. Are you actually cutting a piece to match a maquette?

JVA: Landing large commissions can be really tough for me. I present a scale model, but there is no way that I want to go out and try to chip a large stone into that exact shape. It would never have a sense of spontaneity or freshness that I feel my work demands. So I'm always making qualifications, saying "This is the spirit of the work, and we will find a stone that will convey those same movements and characteristics, but it's not going to be exactly the same—hopefully it will be better!" The trick is to get the client or committee to trust you so they are comfortable with this way of working; sometimes that's hard.

GH: Your public works have their own distinct imagery, they don't just use the smaller works as a template. How did that develop?

JVA: I had a chance to spend time in England and visited many standing stone sites. It got me thinking much larger, thinking about placing stones in a way that would track larger landscape forms or the movement of the earth and ultimately create work with a more meaningful connection to their site or setting. *Trough*, 1982 (p. 56), my first large scale public piece, in Billings Montana, consists of two large slabs of granite held in perpetual suspension by two interlocking linear steel elements. In addition to being the climax of my early "tension" pieces in terms of scale and raw power, the physically charged negative space created between these very large "arrested" stones was designed to echo the main geological formation in the area, an impressive trough cut through the high plains by the Yellowstone River. This connection helps "seat" the work in its locale and imbue it with even greater power.

Other public art pieces were in part influenced by sites out West, like the Anasazi sun dagger, as well as Meso-American pyramids and observatories. *Solstice Calendar*, 1986 (pp.56-59), built for Austin College in Sherman, Texas, for instance, has two large, 22-foot high columns of stone connected near the top with a four-inch diameter stainless steel rod. The work is aligned north/south so that on the summer solstice, light from the noon sun (which is then at its highest) passes light through the columns and creates a shadow which aligns with the solstice bar on a third, low horizontal stone element. Each day that follows the noon sun is a bit lower, creating a shadow a little further down the horizontal stone. It reaches the equinox marker on or around March 20, continuing until it arrives at the winter solstice bar, where it reverses course and returns to complete the cycle. The sense of time, space, place and the cyclical nature of our existence evoked by the work transcends its physicality. It is successful both because it directly addresses the ideas of site-specificity and placement and also provides multiple points of access, allowing a "public art audience" to make a meaningful connection.

GH: In a catalogue for a 1998 exhibition at the Plattsburgh State University Art Museum, you used the word "impure" to describe your materials, in particular the found objects.

JVA: Found objects are never "pure" in the sense that they are imbued or tainted with layers of information, history, associations, symbolism as a result of our individual experience with them in the "real" world. Combining them together and with natural objects, like stones, can result in a combustible mix that one can mine for information and elicit emotion, compassion, and reaction.

GH: More recently, you've included another category of found objects, animal horns and other organic forms. What led you to use those natural forms?

JVA: The introduction of organic, animal horns and other nautilus-like forms is really a spin-off from the arc that I've used a lot, a pure geometric shape that is an ideal link between disparate materials. I've been looking for ways to expand that idea. Currently I live in the Adirondack Mountains where hunting is a big part of the history and culture. You see a lot of mounted trophy heads—taxidermy is big, in a way it is a local form of sculpture. I find many of the horns very exciting from a purely formal aspect. Plus, like in *Almathea II*, 1998 (p. 45) and *Hornhammer (Rouge)*, 1998 (p. 48), their use adds all kinds of interesting symbolism and associations that can be woven into the intent and content of the work. Once they are cast in bronze, you can weld them and use them as you would any metal element. I'm not sure where it all will lead, but it seems interesting at the moment.

GH: Your use of color has changed from the stone and steel works to pieces with applied color to the combination of bronze and stone.

JVA: The stone in the early stacked pieces is Colorado flagstone, it's a kind of neutral "pukey" pink in color. You'd stack it on the truck and it would scrape and take its own marks of use, creating an interesting patina and revealing in a sense its history. Because the stones were all flat and rectilinear, the marks began to appear like writing on a tablet, in a way describing what they were and where they had been. That weird color was wonderful because I wanted the viewer to focus on the stone's volume, its weight, its history, its geological layering, not how pretty it was. I have always been put off by stones that seem too "pretty" or polished and look like plastic. They attract attention for the wrong reason and seem too sweet. They hurt my "aesthetic" teeth.

In some later pieces I added color to the stone, thinning enamel and letting it soak in. This was influenced partly by living in the West where I came across stones that seemed unreal because of their crazy shades of gold or yellow. By slightly tinting the stones in the sculpture, I was able to tap into a similar sense of mystery, getting to the point where most people didn't know if the color was real or altered. This created an interesting tension. When I started to use bronze one of the things I discovered was the appealing range of color available though the patina process. They were very subtle and natural, and that struck a cord with my "ceramic glaze" sensibility. As you can see I tend to cycle in and out of different phases with color.

GH: How does that sense of color relate to the more recent pieces with additive color?

JVA: The addition of color on pieces like *Drastic Measures*, 1984-7 (p. 18) or *Luna*, 1985 (p. 21), and others done around the same time, came as a spin-off of my work with pastel drawings. At that time I was using mostly gray granite and steel, which can be very monochromatic, and I got to a point where I felt I needed more color excitement. This use of color differed from the very early painted works that were more like stoneware glazes. Muted very earthy and very low-key colors were influenced by my work as a potter.

GH: In some of the more recent pieces, like *Cudgel Column*, 1999 (p. 54), there is a lot of color?

JVA: Yes, I guess that's my recent reaction to late winter in the Adirondacks, it seems mostly gray up there then. I started experimenting with color again, with very flat enamels, first applying different and distinct color on each of the geometric elements of a work, and staining the stone. By the end of that series (there were five columns) I began blending the colors, rubbing through them with solvents to reveal some of the layers underneath. To mute things a bit I added dark sprays, working the surface like my drawings. I guess working through the cycle I ended up near, but not quite, where I started. This happens a lot with my work, it's one way it grows. I push out in a new direction, reaching a point of being uncomfortable and then cycle back, hopefully not to the exact spot, stay there for a while, then launch out again.

GH: When did you start working in bronze?

JVA: Somewhere around 1988–89. There were a couple of reasons: maintenance of outdoor works, and I wanted to re-use some of the particularly interesting found objects in several different pieces. I work with a foundry in Brooklyn that does sand casting, and that is great for me, because 99 percent of my pieces are unique. The fact that I am not usually interested in editions makes sand casting efficient and reasonably economical. I take parts that need to be cast to the foundry and retrieve their bronze counterparts just the way they come out of the sand. I like the rips, tears, and textures that occur during the casting process. I approach them like new found objects, accepting and incorporating their new information into the piece. Once back in my studio, the bronze is fit with the stone and I do whatever welding or pinning that is needed, then the patina is applied. Casting both expands what I can do with the objects and introduces fresh important new information to the mix.

GH: Your work has a suggestive rather than a linear relationship with the mythologies and the histories and landscapes that you refer to. Do you think that comes from the additive way that you work?

JVA: I think so, as I'm putting objects together I try to be very mindful as to their individual associations, their past histories, and ultimately what they will communicate when combined. Sometimes when working, a mythological reference or interesting notion about the landscape will suggest itself which provides a vehicle for comment or communication. I guess the trick is to be ready or open to those suggestions when they arise. Like most artists, I'm looking for common truths or conditions that not only speak to me but connect to a broader audience.

GH: All your work, not just the large public art, has an epic quality – suggesting the sweep of human history, a larger language or scope. Is that an outgrowth of a conscious choice to look in the long view, the large scale?

JVA: Yes, in my mind significant sculpture or art strives to reveal universals, rather than being navel-oriented. I'm interested in making statements or raising questions that generate discussions on broad, universal topics, uncovering truths that resonate and echo. I see my work, at its best, as a lens that can help provide focus to a "big picture".

Photograph: Robert Sliclen

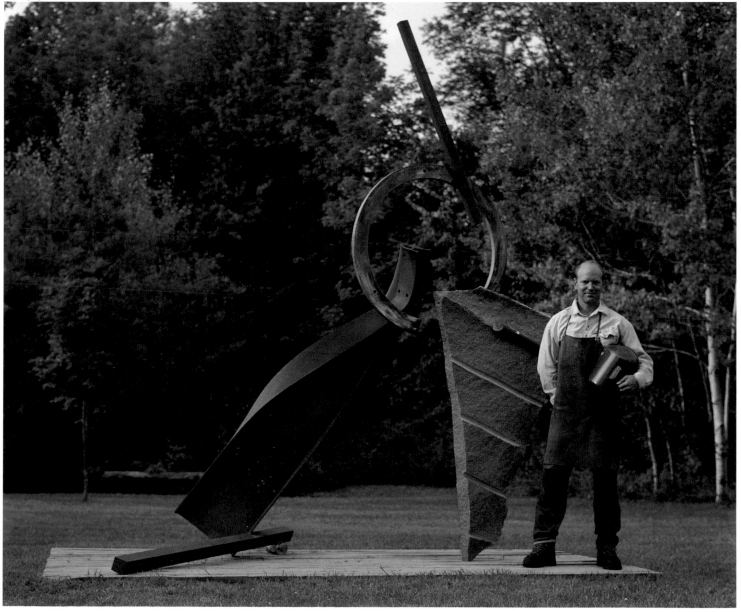

Biography

JOHN VAN ALSTINE b. 1952
P.O. Box 526 • Wells, New York 12190
Tel & Fax: 518-924-9204
E-mail: jva@superior.net • http://jvasculp.superior.net

EDUCATION

Cornell University, Ithaca, New York; Cornell Graduate Fellowship in Sculpture; M.F.A.
August 1976 Kent State University, Kent, Ohio; graduated cum laude, 1974, with B.F.A.
degree in Sculpture, Ceramics and Glass Blossom Festival School, Cleveland-Kent, Ohio,
1973; full scholarship in sculpture; worked with Richard Stankiewicz and Richard Hunt
St. Lawrence University, Canton, New York; attended 1970-71

AWARDS, GRANTS, FELLOWSHIPS, SCHOLARSHIPS

1996 Resident Fellowship, Casting Institute, Art Department, SUNY at Buffalo, NY
1994 Development Grant - New York State Artists, Empire State Artists Alliance
1988 Individual Artist Fellowship, New Jersey State Council on the Arts
1986 Individual Artist Fellowship, National Endowment for the Arts, Sculpture
1985 Yaddo Fellowship, Saratoga Springs, New York, July/August
1984 Individual Artists Fellowship, New Jersey Council on the Arts
1983 Creative and Performing Arts Award, University of Maryland
1981 District of Columbia Commission on the Arts -- Individual Artist Fellowship
 Creative and Performing Arts Award, University of Maryland
1980 Louis C. Tiffany Foundation Individual Artist Fellowship -- Jurors: Suzanne
 Delehanty, Dimitri Hadzi, Lee Hall, and Marcia Tucker
 Individual Artist Fellowship (photography), Wyoming Council on the Arts
1979 Grants-in-aid. University of Wyoming, for work and study at Italy (Pietrasanta)
 Summer 1979
1978 Finalist for 1978-79 Rome Prize Fellowship in Sculpture
1974-5 Cornell Graduate Fellowship in Sculpture
1973 Blossom Festival School of Art, Full Scholarship in Sculpture, Kent-Cleveland, OH

PUBLIC COLLECTIONS (Selected)

BALTIMORE MUSEUM OF ART, Baltimore, MD
CARNEGIE INSTITUTE OF ART, Pittsburgh, PA
CORCORAN GALLERY OF ART, Washington, DC
DALLAS MUSEUM OF ART, Dallas, TX
DELAWARE MUSEUM OF ART, Wilmington, DE
DENVER ART MUSEUM, Gift of List Foundation, NYC
MR. & MRS. ROBERT LEVI FOUNDATION, Baltimore, MD
HIRSHHORN MUSEUM AND SCULPTURE GARDEN, Smithsonian Institution,
Washington, DC
THE MUSEUM OF FINE ARTS, HOUSTON, Houston, TX
HERBERT F. JOHNSON MUSEUM OF ART, Cornell University, Ithaca, NY
NATIONAL MUSEUM OF AMERICAN ART, Smithsonian Institution, Washington, DC
FEDERAL RESERVE BOARD, Washington, DC
NEWARK MUSEUM OF ART, Newark, NY
MUSEUM OF MODERN ART, GULBENKIAN FOUNDATION, Lisbon, Portugal
PHOENIX ART MUSEUM, Phoenix, AZ
THE PHILLIPS COLLECTION, Washington, DC
U.S. STATE DEPARTMENT, Art in Embassies / Bolivian Embassy, Washington, DC

SOLO EXHIBITIONS (Selected)

NOHRA HAIME GALLERY, New York City, 2000, 1998, 1996, 1994, 1991, 1990, 1988
HYDE COLLECTION ART MUSEUM, "CONFLUENCE" Glens Falls, NY, Jan-April 1999
GRIMALDIS GALLERY, Baltimore, 1999, 1997, 1995, 1992, 1984
WOOD STREET GALLERY and SCULPTURE GARDEN, Chicago, 1999
STATE UNIVERSITY OF NEW YORK, PLATTSBURGH, ART MUSEUM,
"Acknowledging the Figure" 1998
DeCORDOVA MUSEUM, Lincoln, Mass. "Vessels and Voyages", June 1996-June 1997
KENDALL CAMPUS ART GALLERY, Miami-Dade Com. College, Miami, FL, Oct. 1997

DARTMOUTH COLLEGE, Studio Art Exhibition Program, Sept.- Nov. 1995
UNIVERSITY OF NEW HAMPSHIRE, Paul Creative Arts Center, Durham, NH,
Oct.-Dec. 1994
TROYER FITZPATRICK LASSMAN GALLERY, Washington, DC, Sept.-Oct. 1994
CLEVELAND STATE UNIVERSITY, Art Gallery, Cleveland, OH, April 1994
SUN VALLEY CENTER FOR THE ARTS, Sun Valley, ID, February 1993
SONSBEEK INTERNATIONAL ART CENTER, Arnhem, The Netherlands, Sept.-
Nov. 1991
NATIONAL ACADEMY OF SCIENCES, Washington, D.C., "Documents" (drawings
and related documents produced in conjunction with large scale site-specific solstice
projects), Jan.-Mar., 1991
MORRIS MUSEUM, Morristown, NJ, "New Jersey Artist Series," January/March, 1991
FRANZ BADER GALLERY, Washington, D.C., February, 1991
GERALD PETERS GALLERY, Santa Fe, NM, 1991, 1989
FRANZ BADER GALLERY, Washington, D.C., "New Work/Raw Space," special
exhibition in conjunction with the international Sculpture Conference, 1990
JERSEY CITY MUSEUM, Jersey City, NJ, 1988, Sponsored in part by the New Jersey
Council on the Arts
GEORGE CISCLE GALLERY, Baltimore, 1988, 1986
PHILLIPS COLLECTION, Washington, D.C., April-June, 1987
MUSEUM OF THE NATIONAL ARTS FOUNDATION, 75 Rockefeller Plaza, NYC,
May 1987
OSUNA GALLERY, Washington, D.C. 1989, 1985, 1983, 1981
DIANE BROWN GALLERY, New York, NY, 1984
ST. LAWRENCE UNIVERSITY, Brush Gallery, 1984
HENRI GALLERY, Washington, D.C., 1981
MICHIGAN STATE UNIVERSITY, 1980
UNIVERSITY OF COLORADO, Boulder, 1980
NEILL GALLERY, New York, NY, 1979
COLORADO STATE UNIVERSITY, Fort Collins, 1978
NORTHERN ARIZONA STATE UNIVERSITY, Flagstaff, 1977
HERBERT F. JOHNSON MUSEUM, Cornell University, 1976

GROUP EXHIBITION (Selected)

1999 INDOOR/OUTDOOR SCULPTURE, Nohra Haime Gallery, NYC, June-July
PORTALS, Outdoor public sculpture exhibition, curated Sarah Tanguy, Washington, DC
PIERWALK 99, International outdoor sculpture exhibition, Chicago Navy Pier, May-Oct.
EQUILIBRIUM OF THE SENSES, Nohra Haime Gallery, NYC, Jan.-Feb.
MAQUETTE EXHIBITION - Pierwalk '99, international sculpture exhibition, Vedanta
Gallery, Chicago, Jan.-Feb. 10 by 10, Addison/Ripley Gallery, Washington, DC, Jan.-Feb.
SMALL SCULPTURE, Grimaldis Gallery, Baltimore, Jan.-Feb. 1998
ANNMARIRIE GARDENS, "New Stone and Steel Sculpture, Solomons, MD
GRIMALDIS GALLERY, SUMMER 98 - Elaine DeKooning, Hartigan, Kenndrick,
Ruckriem, Ruppert, Serra, Van Alstine and more, Baltimore MD
PIERWALK 98, International outdoor sculpture exhibition, Chicago Navy Pier, May-Oct.
WOOD STREET GALLERY, Maquette Exhibition - Pier Walk "98, Chicago, January -
March 1997
HIRSHHORN MUSEUM, "The Hirshhorn Collects: Recent Acquisitions 1993-96",
Washington, DC
FIAC, "Drawings", Nohra Haime Gallery, Paris, France, October
SOCRATES SCULPTURE PARK, "From the Ground UP", NYC, May - Sept.
CHICAGO NAVY PIER, "Pier Walk '97", Chicago, May-Oct.
NATIONAL BUILDING MUSEUM, Smithsonian Institution, "Tool as Art II, Exploring
Metaphor -The Hechinger Collection , Curated by Sarah Tanguy, Washington, DC,
April-September.
NOHRA HAIME GALLERY, " Works on Paper", New York, January
PLATTSBURG MUSEUM, State University of New York, "Inaugural Exhibition-
Sculpture Terrace", Oct. 1996
FIAC, "Sculpture" Nohra Haime Gallery, Paris, France
CERRILLOS CULTURAL CENTER, "C3: Beasley, Henry, Hunt, Jimenez, Moroles,

Scholder, Surls, VanAlstine, Whitney, I. Witkin and others" Cerrillos, NM, July–August
GRIMALDIS GALLERY, "SUMMER '96, Part I-The Sculptors: Isherwood, Kendrick, Ruckriem, Ruppert, Van Alstine", Baltimore, June 1995
NJ CENTER FOR THE VISUAL ARTS, "The Creative Process: Drawings by Sculptors", Sept. 1995
INTERNATIONAL SCULPTURE CENTER, "Metamorphosis: Contemporary Sculpture at Tudor Place, Washington, DC, Summer/fall
PHILLIPS COLLECTION, "Recent Acquisitions", Washington, DC, Spring/Summer
ART INITIATIVES /NYC "SEMAPHORE: Placing the Mark", curated by Bill Bace
1994 HAKONE OPEN-AIR MUSEUM, "2nd Fujisankei Biennale, Ninotaira, Japan
1993 NOHRA HAIME GALLERY, "Contemporary Sculpture", New York, September
GRIMALDIS GALLERY, "Sculptor's Drawings: Anthony Caro, Joel Fisher, Jene Highstein, David Nash, Joel Shapiro, John Van Alstine", Baltimore, March 1992
FEDERAL RESERVE BOARD, ART COLLECTION OF THE NATIONAL RESERVE BOARD, "Five Years of Accessions" June - August , Washington, DC
NOHRA HAIME GALLERY, "Vara, Mutal, Van Alstine", New York, March
NOHRA HAIME GALLERY, "10th Anniversary Exhibit", New York 1991
GRIMALDIS GALLERY, "Caro, Kendrick, Ruppert, Van Alstine", Baltimore, July–August
CONGRESS SQUARE GALLERY, "Sculptors on Paper," Portland, ME, March
INDIANA UNIVERSITY MUSEUM, "Object/Context: A National Invitational," Indiana University of Pennsylvania, Indiana, PA, April
GRIMALDIS GALLERY, "Ruppert/Van Alstine" two person show, Baltimore, May
NOHRA HAIME GALLERY, "Selections," New York, May 1990
FRANZ BADER GALLERY, "Washington Artists: Those Who Left, Those Who Stayed," Washington, D.C.
MUSEUM OF MODERN ART OF LATIN AMERICA, ORGANIZATION OF AMERICAN STATES, "Sculpture of the Americas into the 90's," Washington, D.C.
FARNSWORTH MUSEUM, "Voyages of the Modern Imagination: The Boat in 20th Century Art," Rockland, ME
PORTLAND MUSEUM OF ART, "The Boat Show," Portland, ME. Exhibition organized by the RENWICK GALLERY Smithsonian Institution, Washington, D.C.
NOHRA HAIME GALLERY, "Salon de mars," Paris 1989
NOHRA HAIME GALLERY, "Selections," New York
INDIANA UNIVERSITY, "Sculpture Invitational: John Van Alstine and David Maxim," Indiana, PA 1988
NOHRA HAIME GALLERY, "Blues and Other Summer Delights," New York
FRICK GALLERY, "About Seascape," Belfast, ME
NOHRA HAIME GALLERY, "Small Sculpture," New York 1987
NEW JERSEY ARTS COUNCIL, MORRIS MUSEUM, "Artists Fellowship Exhibition," NJ
NOHRA HAIME GALLERY, "Watercolors Plus," New York
NOHRA HAIME GALLERY, "Inaugural Exhibition," New York
SIBLE LARNEY GALLERY, "Los Gringos," Chicago, IL 1985
NEWARK MUSEUM, "New Jersey Artists Biennial," New Jersey
DIANE BROWN GALLERY, "Drawings By Sculptors," New York
GEORGE CISCLE GALLERY, "Discoveries and Disclosures," Baltimore, MD 1984
DIANE BROWN GALLERY, "Timely Objects," Inaugural Exhibition, New York 1983
SARAH LAWRENCE COLLEGE, "International Arts Council Exhibit," Bronxville, NY
BALTIMORE SCULPTURE Works in Public Sites, Mayor's Advisory Council on the Arts, Baltimore, MD
COLBY-SAWYER COLLEGE GALLERY, "Colby-Sawyer College National Invitational", London, NH
WASHINGTON PROJECT FOR THE ARTS, "Flatworks -- Non 3-D works by Sculptors" Wash, DC 1982
INTERNATIONAL SCULPTURE CONFERENCE, San Francisco, CA, "10 Washington Sculptors," curated by Howard Fox 1982
GRANTEES EXHIBITION, DC ARTS COMMISSION Washington, D.C., Oct.–Nov.
OSUNA GALLERY, "Gallery Stable Sculpture," Washington, D.C. 1981
MARLBOROUGH GALLERY, "Color-Five New Views" photography, New York, NY 1980
HIRSHHORN MUSEUM, "Recent Acquisitions," Washington, D.C.
1979-80 -- First Western States Biennial Tour: DENVER ART MUSEUM, SAN FRANCISCO MUSEUM OF ARTS; SEATTLE ART MUSEUM, NATIONAL MUSEUM OF AMERIACAN ART, Washington, D.C.
1979 HIRSHHORN MUSEUM, "Directions '79," curated by Howard Fox, Washington, D.C.

1978 HERBERT F. JOHNSON MUSEUM, Cornell University, "Cornell Then/Sculpture Now," Ithaca, NY

INSTALLATIONS
THE PHOENIX ART MUSEUM, museum entrance, Phoenix, AZ 1997-
STATE UNIVERSITY OF NEW YORK, Plattsburgh
DE CORDOVA MUSEUM AND SCULPTURE GARDEN, Lincoln, (Boston) MA, 1997-
HIRSHHORN MUSEUM SCULPTURE GARDEN, permanent collection, lower garden 1982-96
SOCRATES SCULPTURE PARK, New York City, 1997-8
PHILLIPS COLLECTION, Washington, D.C., 1995-7, Large scale sculpture at museum entrance
AMERICAN INSTITUTE OF ARCHITECTS HEADQUARTERS, Washington, D.C., Spring 1983

LARGE SCALE OUTDOOR SCULPTURAL COMMISSIONS
JERSEY CITY STATE COLLEGE, funded by New Jersey State Council on the Arts. 1994
ARTERY PLAZA HEADQUARTERS, Bethesda, MD, for the Artery Organization Inc., 1993 18' bronze and granite, Solstice Calendar.
DEMOCRACY PLAZA, Washington, D.C., for the Artery Organization Inc., 1988-89
INSTITUTE FOR DEFENSE ANALYZES, Super Computing Research Ctr., Washington, D.C., 1988-89
AUSTIN COLLEGE, Sherman, TX. Funded in part by the Texas Council on the Arts and the National Endowment for the Arts
OUTDOOR PUBLIC SCULPTURE, Billings, MT. Funded by American Linen Co., Burlington Northern Railroad, Ravenhust Corp., First Northwestern National Bank.
OUTDOOR SCULPTURE -- LUCK STONE CORPORATION, Richmond, VA, 1983

VISITING ARTIST LECTURES
1999 Hyde Collection Museum of Art, Glens Falls, NY
1997 State University of New York at Plattsburgh, Art Department - Visual Artist Series
 Kendall Campus Art Gallery, Miami-Dade Community College, Art Department, Miami, FL
1996 State University of New York at Buffalo, Art Department/Casting Institute
1994 University of New Hampshire, Durham, NH
 Cleveland State University, Cleveland, OH
1991 North Carolina Center for the Advancement of Teaching, Cullowhee, NC
1990 Anderson Ranch, Aspen/Snowmass, CO
 Indiana University, University of Pennsylvania, Indiana, PA
1989 College of Ceramics, Alfred University, Alfred, NY
1987 Maryland Art Institute, Baltimore, MD
1986 Austin College, Sherman, TX
1985 Montclaire State College, Montclaire, NY
 University of Texas, Houston
1984 St. Lawrence University, Canton, NY
1982 George Mason University, Fairfax, VA
1981 Hirshhorn Museum and Sculpture Garden
 University of Maryland, College Park, MD
 Arvada Center for the Arts, Denver/Arvada, CO
 Penn State University
1980 University of Denver, CO
 University of Cincinnati, OH
 Eastern Montana College, Billings, MT
 University of Colorado, Boulder, CO
1979 Colorado College, Colorado Springs, CO

EXHIBITION CO-CURATED
1983 FLATWORKS-NOW 3 DIMENSIONAL WORKS BY SCULPTORS, Washington Project for the Arts, Washington, D.C.

SELECTED BIBLIOGRAPHY
Baltimore Sun, "The Play of Gravity at Grimaldis" Glenn McNatt, June 24, 1999 (photo)
Baltimore Sun, "Objects Captured in Motion" review, Glenn McNatt, June 22, 1999 (photo)
City Paper, (Baltimore), "Rocks of Ages" review, Mike Giuliano, June 23, 1999 (photo)
Exhibition Catalog, "Confluence", John Van Alstine, Hyde Collection Art Museum, Glens

Falls, NY., 1999, (photos and interview)
Exhibition Catalog, "Acknowledging The Figure", John Van Alstine, Art Museum, State Univ. of New York, Plattsburgh, Sept.-Oct.1998, (photos and essay)
Baltimore Sun, "…Talent pool deep", John Dorsey, July 21, 1998, (photo)
Adirondack Life Magazine, 1998-99 Collector Issue, "Through the Mill" , Karen Bjornland, pp. 76-82 (photos)
Cover Magazine, "John Van Alstine: Choreographing Steel and Stone", Jeffrey C. Wright, Vol. 12, No. 2, 1998 (photo).
Exhibition Catalog, "The Hirshhorn Collects: Recent Acquisition 1992-96" Published by Hirshhorn Museum and Sculpture Garden, Smithsonian Institution, Washington, DC., p.103, (photo).
Exhibition Catalog, "Sculpture and Drawings" Kendall Campus Art Gallery, Miami-Dade Com. College, October 24 - November 14, 1997, (photos and essay).
Baltimore Sun, Review, "John Van Alstine - At Grimaldis, a horn of plenty", John Dorsey, June 10, 1997, p3E (photos).
Art News, Review, "John Van Alstine" , Valerie Gladstone, November 1996, (photo).
Sculpture Magazine, Review, "Van Alstine: Vessels & Voyages" at DeCordova Museum, Miles Unger, October 1996, p61 (photo).
Exhibition Catalog, "John Van Alstine: Solo Exhibition, Nohra Haime Gallery, NYC, September 96, (photos).
Boston Globe, Review, "Sculpture terrace... DeCordova", Christine Temin, July 31, 1996, p.E1 & E6 (photos).
Boston Sunday Globe, "'Heavy' Art Christens DeCordova Terrace" July 7, 1996 (photos).
Exhibition Catalog, "John Van Alstine: Vessels and Voyages" essay by Nick Capasso, DeCordova Museum, Lincoln, Ma., June 1996, (photos).
"Tool as Art: The Hechinger Collection" by Pete Hamill, Harry N. Abrams, Inc., *Publisher*, 1995 pp.15 (photo), 171, 203.
Newark Star-Ledger, Review, "Creative Process Exhibition", Eileen Watkins, Sept 22,1995, p.48 Wkend, (photo).
Baltimore Sun, "Van Alstine" Review, John Dorsey, June 21, 1995, p.8D, (photo).
Baltimore City Paper, "Heavy Metal" Review, Mike Giuliano, June 14, 1995, (photo).
Arts and Antiques, "Openings: Staking Out Claims", Eric Gibson, September 1994, p.32. (photo).
Noticias de Arte, Ronda De Galerias, "John Van Alstine Y El Equilibrio", Angel Lopez, Julio 1994, p.5 (photo).
Exhibition Catalog, "John Van Alstine" Solo Exhibition, Nohra Haime Gallery, NYC, June 1994, (photos).
Exhibition Catalog, "John Van Alstine: Sculpture Between a Rock and a Hard Spot", David Gariff, Cleveland State University Art Galley, April 1994, (photos and essay).
Baltimore Sun, "…expressive range" Review, Robert Haskins, September 3, 1992, p2F, (photo).
De Gilderlander (the Netherlands), Review, Jan Nieland, October 4, 1991, (photo).
Tableau Magazine (the Netherlands), Review, September 1991(photo).
Arnhemse Courant, (the Netherlands), Review, Jan van Krieken, September 26, 1991, (photo).
Santa Fe New Mexican, "John Van Alstine/ Romancing the Stone and Steel" Review, Ellen Zieselman, September 13, 1991, Pasatiempo sec. p.10, (photo).
Santa Fe New Mexican, Review, Zeke Zemaitis, September 27, 1991, Pasatiempo sec. p.37, (photo).
Baltimore Sun, "Dual Exhibit . . . Complements Artists," Review, John Dorsey, May 2, 1991, sec. E (photo).
Baltimore Sun, "Sculptors with a Lot in Common," John Dorsey, May 19, 1991, p. 1N (photo).
New York Times, "Urban-Suburban Scenes and Unlikely Shapes," Vivien Raynor, Sunday, January 27, 1991, NJ sec., p. 16.
Washington Post, "Lessons of Sun and Land," Hank Burchard, Weekend Magazine, January 18, 1991.
Exhibition Catalog, "Fantastic Vessels, Fictional Voyages" Portland Museum , Maine, Aug.- Oct 91.
Exhibition Catalog, "Documents/ Van Alstine Solo Exhibit" Philip M. Smith, National Academy of Sciences, Washington, D.C., January-March 1990.
IMZUE (Japan), Summer 1990, no. 955, p. 123 (photo).
Cover Magazine, "John Van Alstine," Gloria Amann, September, 1990 (photo).
Washington Post, "Van Alstine's Balancing Act," Micheal Welzenbach, May 20, 1988, Sec. C2, p. R1 (photo).

New York Times, "Ephemeral Pairing of Granite and Steel," William Zimmer, Sunday, January 8, 1989, NJ sec., p. 22 (photo).
Newark Star-Ledger, "John Van Alstine," Review, John Dorsey, May 11, 1988, p. E1 (photo).
Jersey Journal, "Reaching Skyward," Jane Greestein, January 6, 1988, sec. 4, p. 16 (photos).
Baltimore Sun, "John Van Alstine," Review, John Dorsey, May 11, 1988, p. E1 (photo).
Washington Post, "John Van Alstine," Review, Paul Richard, October 17, 1985, p.B6 (photo).
New Art Examiner, "John Van Alstine," Review, Ann Markovich, October, 1984, p. 52 (photo).
Baltimore Sun, "Van Alstine Sculpture," Review, John Dorsey, April 12, 1984 (photo).
Washington Post, "Living Steel and Stone, sculpture of John Van Alstine," Paul Richard, May 21, 1983 (photo).
Washington Times, "Playful Sculpture," Jane Addams Allen, May 19, 1983 (photo).
Art In America, "John Van Alstine," David Tannous, December, 1981 (photo).
Art Forum, "Color-Five New Views," Review, Marlborough Gallery, NYC, October 1981 (photo).
New Art Examiner, "John Van Alstine," Review, Jan Allen, November, 1981 (photo).
Washington Post, "Van Alstine's Photography -- Allowing a Fresh Look at the Land," Paul Richard, February 7, 1981, p. C1(photos).
Washington Star, John Van Alstine, Review of Photos, James Caselles, January 25, 1981.
Arts Magazine, John Van Alstine, review, January, 1980, vol. 54, no. 5, p. 35 (photo).
Washington Post, "Wild & Witty, Western States Biennial," Paul Richard, June 7, 1979, p. C17.
Washington Post, "The Hirshhorn: Steps in the Right Directions," Paul Richard, June 14, 1979, p. C1, C2.
Smithsonian Magazine, "A Move to the Edge, V.S. Art Focus Toward the Pacific," William Marvel, vol. 10,. no.1, April, 1979
Smithsonian Press, Exhibition Catalog, DIRECTIONS, Howard N. Fox, p. 10, 48-50 (photo).
Denver Post, "Western State Biennial," James Mills, March 18, 1979, p. 31, 32 (photo).
Kansas City Star, "Beyond Mere Images . . ." Marietta Dunn, March 18, 1979, p. 8E.

UNIVERSITY AFFILIATIONS

1995 State University of New York at Buffalo, Resident Fellow, Casting Institute, Art Department
1988 Maryland Art Institute, Baltimore, MD, Visiting faculty (fall)
1982-86 University of Maryland, College Park, MD, Assistant Professor
1980-81 University of Maryland, College Park, MD, Visiting Lecturer
1976-80 University of Wyoming, Laramie, WY, Assistant Professor
1975-76 Cornell University, Ithaca, NY, Teaching Assistant

CORPORATE COLLECTIONS (Selected)

Artery Organization, Bethesda, MD
Harris Trust & Savings Bank, Chicago, IL
Hechinger Company, "Tools AS Art: The Hechinger Collection, Largo, Maryland
MCI Corporation - East Coast Headquarters, Arlington, VA
Prudential Life Insurance, Newark, NJ
Mountain Bell, Denver, CO
Norwest Bank, Billings, MT
Peat Marwick Inc., Montvale, NJ
Rouse Company, Baltimore, MD
Progressive Corporation, Cleveland, Ohio
Gulf Co., Aspen, CO